IMAGES
of America

PORTLAND'S
PEARL DISTRICT

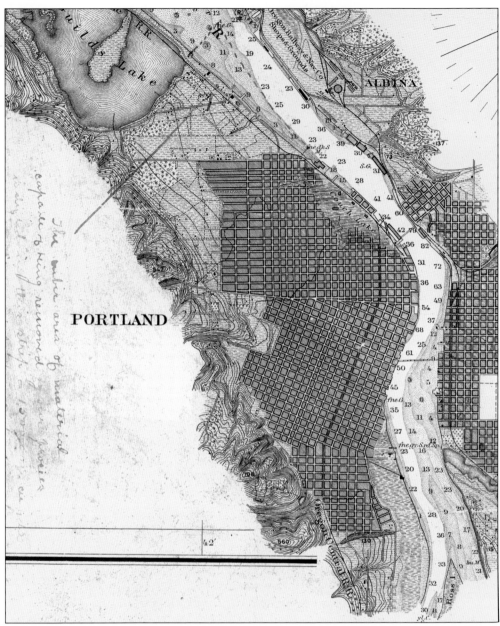

This is a portion of an 1896 Cleveland Rockwell map of Portland. Couch Lake, where Union Station will eventually be built, is on the west bank of the Willamette River at the north end of town in the midsection of the map. (Courtesy of the Oregon Historical Society.)

ON THE COVER: This photograph was taken looking west on West Burnside Street at Fourth Avenue in 1930. (Courtesy of the City of Portland Archives.)

IMAGES
of America

PORTLAND'S
PEARL DISTRICT

Christopher S. Gorsek

ARCADIA
PUBLISHING

Published by Arcadia Publishing
Charleston, South Carolina

Printed in the United States of America

Library of Congress Control Number: 2011944533

For all general information, please contact Arcadia Publishing:
Telephone 843-853-2070
Fax 843-853-0044
E-mail sales@arcadiapublishing.com
For customer service and orders:
Toll-Free 1-888-313-2665

Visit us on the Internet at www.arcadiapublishing.com

To my wife, Jackie, and my children, Annie and Christopher.
I love you and appreciate your patience and support.

CONTENTS

Acknowledgments 6

Introduction 7

1. The Early Landscape 11

2. The Early Industrial Period 17

3. The Postwar Industrial Era 67

4. Declining Industrial Activity 97

5. An Emerging Urban Oasis 111

ACKNOWLEDGMENTS

My interest in this area dates back to my childhood and my love of trains. However, my deeper exploration of this landscape occurred due to the inspiration of Dr. Joe Poracsky, one of my college professors in geography at Portland State University. He suggested that I research past Portland landscapes and lost natural elements like lakes and streams when I was still a master's degree student at the University of Oregon. That topic has certainly been a large part of the Pearl District's history. My love of urban history was also inspired by the courses that I took from Dr. Carl Abbott in the urban studies doctoral program at Portland State University.

Without the assistance of a number of professionals in the field, this book would not have been possible. I have received a great deal of help in this endeavor from the staff of the research library at the City of Portland Archives, especially from assistant archivists Mary B. Hansen and Brian K. Johnson.

I have also received important assistance from the staff at the research library of the Oregon Historical Society, especially from research librarian Scott Daniels and digital assets manager Scott Rook. Finally, I wish to thank associate publishers Donna Libert and Elizabeth Bray at Arcadia Publishing for their guidance and flexibility as I worked my way through this fascinating project.

Unless otherwise noted, all images appear courtesy of the City of Portland Archives.

INTRODUCTION

I grew up in Portland and have been fascinated with its history since I was a child. One of the locations that I have always been drawn to, which has changed considerably during the life of the city and my own life, has been this place in the northwest section of town called the Pearl District, among other designations, depending on where you are located within the district.

In a 1995 document, the Portland Development Commission referred to it as the River District, which it defined as the area bordered by I-405, the Willamette River, and Burnside Street. In a 2008 document, the city again defined the area in that way, with an extension of several blocks along the river north of the previously defined geography. There are several subdistricts within the River District: North Park Blocks, Chinatown, Skidmore/Old Town, the Waterfront area, and the Pearl District. I have chosen to use the Pearl District to identify this entire area, as all of them are very close together and function in many ways as one neighborhood entity. Unlike the River District, it is also the best-known name for this part of town among the general public.

This book then takes you on a journey through the Pearl District's transition from what was there at the time of European American settlement in about 1840 all the way up to the present. My focus will be on five key times in its development: the early natural environment of Native Americans and pioneers, the early industrial phase, the postwar industrial phase, the declining years, and the more recent transition to a viable urban neighborhood with both commercial and residential land uses interspersed amongst some older industrial activities.

In the 1830s, this area was described as grassy open land north of what is today NW Davis Street, while to the south was a forest of mainly fir and oak trees. There was also a lake west of the river, separated from it by a ridge covered with oak trees. Beginning in 1848, John Heard Couch claimed an area north of Burnside Street that included what would become the Pearl District. He owned 640 acres at the site and moved his store from its original location in Oregon City to his Portland claim.

Despite being well liked and successful in Oregon City, Captain Couch moved to Portland because of the problems involved getting large, ocean-going ships as far upriver as Oregon City. His family joined him in Portland in 1852. At that time, Couch lived in a small cabin in the woods near the future site of Union Station. To get to and from Portland, one had to walk along a forested path. He would eventually build a new home in the area of NW Fourth Avenue and Hoyt Street. While this area was a well-to-do section of town at that time, the affluent would move west to Eleventh Avenue, then Nineteenth Avenue, and beyond as industry moved progressively further into the district.

His home on Hoyt Street was built on the west side of the aforementioned lake, which came to bear his name. Couch's home was based on the architecture of the South, with a lawn that stretched down to edge of the lake. Couch Lake itself covered a number of blocks and was located approximately between NW Hoyt Street, NW Front Avenue, NW Park Avenue, and NW Pettygrove Street. It was normally about 15 feet deep, and apparently, Couch used to hunt ducks on it from the front porch of his house.

As in Oregon City, Couch was popular in Portland. When he died in 1870 at 59 years of age, the city stopped to mourn his passing. The following quote is an excerpt from his obituary: "The funeral cortege was never excelled in Portland, in impressiveness and numbers. The banks closed, all business was stopped, labor suspended, and all combined to pay respect and honor."

Native Americans do not appear to have had a permanent presence in this part of the Portland area. However, prior to the coming of the railroad, the peaceful Tualatin Indians would travel to Portland and often camped on Couch Lake. In about 1870, the town marshal was replaced by a police department, made up of seven officers and a chief of police. Native American Tipton Quinn was one of those officers, hired to police the Native American visitors at the lake.

In 1875, St. Vincent's Hospital was built on what is now NW Twelfth Avenue between Marshall and Northrup Streets. Couch Lake was nearby, and during high water, patients could look out their windows and see nothing but water from there to the east bank of the Willamette River. The lake was home to ducks and geese throughout the year. People also picnicked and swam at Couch Lake in warmer weather. This sometimes led to tragedy; two boys drowned in the lake while rafting in 1892. During the winter, ice-skating was the preferred activity on the lake. However, by 1890, news had surfaced that Couch Lake was to be filled in to make way for a new railroad station.

In 1872, horse- and mule-drawn trolley cars first operated downtown on First Avenue between Couch's Addition to the north and Caruthers' Addition to the south. A round-trip covered a distance of three miles and took approximately one hour to complete. Beginning in the 1890s, warehouses, commercial businesses, and some hotels were built between Third and Sixteenth Avenues. They were constructed of brick and built around the railroad activities that were now located north of Hoyt Street.

Many Chinese originally came to Portland to work in railroad construction but decided to stay on in the city once those jobs began to disappear. Portland had a large Chinatown—only San Francisco's was larger. Chinatown was originally located south of Burnside Street and was bounded by Ash Street, Salmon Street, Third Avenue, and the river. The Chinese eventually moved into a portion of the Pearl District north of Burnside Street after a damaging flood in 1894.

Portland in the 1890s and early 1900s was also a focal point of Japanese immigration in the state. Known as Japantown or Nihonmachi, the area, primarily north of W Burnside Street as far as NW Glisan Street and between NW Second and Sixth Avenues, came to provide the needed services, housing, and support for the community, encompassing more than 100 Japanese businesses.

Both Japanese and Chinese children attended Atkinson, the area school. However, tension arose between the two groups due to the Japanese invasion of China in the late 1930s. Once the United States was at war with Japan beginning in 1941, racial tension increased, culminating with President Roosevelt's Executive Order 9066, which essentially put an end to Japantown. Based upon the exclusion orders that followed, people of Japanese ancestry were no longer allowed to live in West Coast cities, while our Chinese allies remained. Fortunately, they were able to return once World War II ended, and from that point on, they moved into neighborhoods all across the Portland area. Many Japanese, like the Naito family, thrived in post–World War II Portland.

By the beginning of the 20th century, most African Americans in Portland lived in an area bounded by NW Montgomery Street, NW Kearney Street, NW Twelfth Avenue, and the Willamette River. This was due to the fact that most of the men worked railroad-related jobs. Here, it was the churches that provided the African Americans with needed social, spiritual, educational, political, and economic support.

In 1910, most Asian Americans lived on the west side of the city, as well as a majority of African Americans. At first, they were integrated into Portland society. However, in the very early 1900s, with European immigration on the rise, that all began to change. African Americans were limited in terms of where they could go for meals, lodging, and entertainment. This spread into the housing arena in the 1920s. Even before World War II, African Americans had been forced into the Albina neighborhood across the river, which was seen as a less desirable place to live. However, the city did pass an anti-discrimination ordinance in 1950.

8

Economic decline in what would become the Pearl District began in the 1950s and extended into the 1960s and 1970s, as warehouses moved to suburban locations better suited to the new single-story, truck-oriented operations. By the early 1970s, the Burnside Street skid row area, located between the river, the Park Blocks, SW Oak Street, and the rail yards near Union Station, was the city's largest. Skid rows are rundown areas of a city occupied by lower-income and homeless individuals. Crime was a serious issue, as the poor residents of this part of town were frequently targeted for theft or robbery when their monthly pension or support checks arrived. Even today, after all of the upscale building in the area, some homeless and near-homeless still live in the area.

While railroad yards in front of Union Station and in the adjacent Hoyt Street Yard were still actively used in the late 1970s, not long after 1980, having outlived their usefulness, they were slowly abandoned. The Union Station Yard was the first to go, but the Hoyt Street Yard soon followed. At Union Station, the number of cars in the yard dwindled down to nothing by 1985. The only operating tracks were those of the mainline, connecting Burlington Northern operations to the north with the large Union Pacific yard across the river and to the north as well as Southern Pacific's Brooklyn Yard to the south. Much of Hoyt Street Yard became a storage area for aging railroad cars and engines, but it, too, eventually emptied out. This left large parcels of land, referred to as brown-field sites, available for new uses close to downtown.

Gentrification appears to have begun in Portland along NW Twenty-third Avenue at the very end of the 1970s. By 1994, many of the warehouses and industrial buildings in the Pearl District were converted into lofts. Art galleries were another large presence in the district at that time. The name Pearl District is attributed to Thomas Augustine, who came up with it while advertising a 1986 arts festival. In naming the district, he was expressing that the dilapidated warehouses possessed pearls within them, such as the art galleries.

Upper-income housing projects soon followed in the 1990s, the first being led by Hoyt Street Properties on the former Burlington Northern Railroad land, known as the Hoyt Street Yard. In 1995, the city planned to transform the riverbank north of the Broadway Bridge into green space and "daylight" Tanner Creek as part of the redevelopment process. While the creek never did get to see the light of day, a vibrant urban neighborhood has evolved over the past 15 years in the former rail yards and warehouse blocks of the Pearl District, and new construction is continuing to fill in the north end of the area. Two new city parks are also found there, one of which commemorates Tanner Creek and the former lakes and wetlands of the original landscape. Thus, the Pearl District has been a place of urban birth, decline, and rebirth, with a nod of acknowledgment and thanks back to its former natural environment.

One

THE EARLY LANDSCAPE

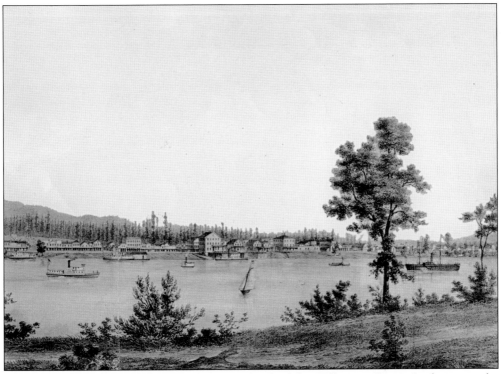

This is Portland in 1858, as seen from the east bank of the Willamette River. At that time, the town was oriented to the river, which was its main mode of transportation. The forest is close by, just to the west of the settlement. Couch's Addition and his cabin are beyond the far right of this photograph, back in the woods. (Courtesy of the Oregon Historical Society.)

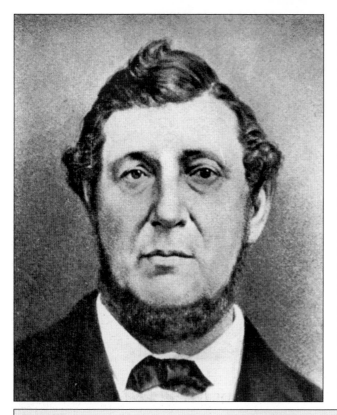

John Heard Couch is pictured here in 1860 at the age of 49. Originally a sea captain, he eventually decided to settle down and open a store, first in Oregon City, then later in Portland. His Portland claim was called Couch's Addition, which included what would become the Pearl District. Couch would go on to begin its transformation from a natural state to an urban industrial landscape.

In this 1850 photograph, Couch's store, located north of Ankeny Street, is on the left facing Front Avenue. The river is directly behind the photographer. Like many Portland buildings of the day, his store was a simple wooden structure, no doubt built with timber from the surrounding forest. (Courtesy of the Oregon Historical Society.)

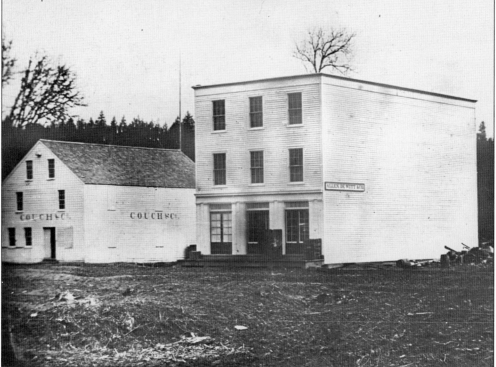

This 1852 map shows the original layout of Portland. Couch's Addition is on the far right of the map, while the Caruthers claim is to the left. Only two small streams are shown in what is today downtown Portland on the left, or south end of town, which are much less substantial than the wetlands and streams of Couch's Addition.

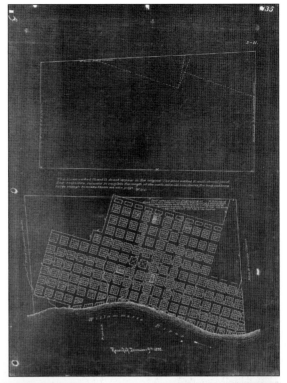

The forest crowds in and around the town in this image by author Joseph Gaston of Portland from Front Avenue in 1854. Couch's Addition would be far off to the right and out of sight of this image but similarly covered with trees.

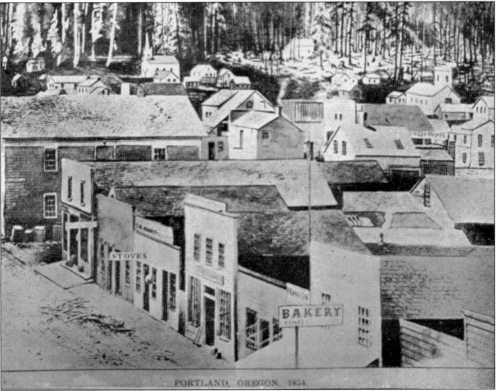

PORTLAND, OREGON, 1854.

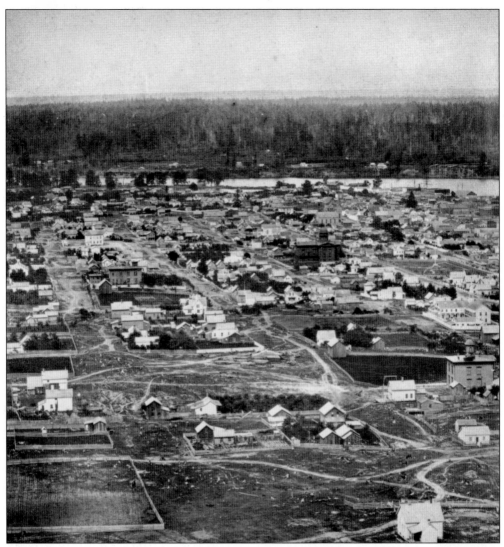

In this 1867 photograph, the forest is visible just across the Willamette River from Portland to the north. Below the river, Couch Lake runs close by and parallel, separated from the river by a narrow ridge with a few trees growing on it. (Courtesy of the Oregon Historical Society.)

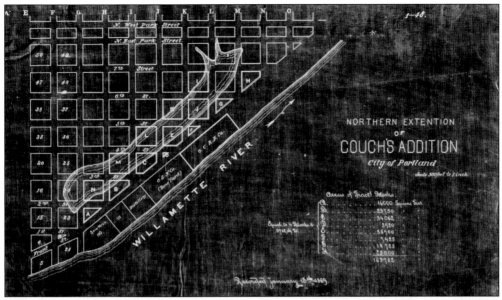

This is a map of a portion of Couch's Addition and Couch Lake in 1869. Like many of the lakes and wetlands in this area, this one was an important habitat for waterfowl. It was also a popular location for recreation, especially considering its close proximity to the main part of town. It was eventually filled in and covered with railroad tracks and industrial activities.

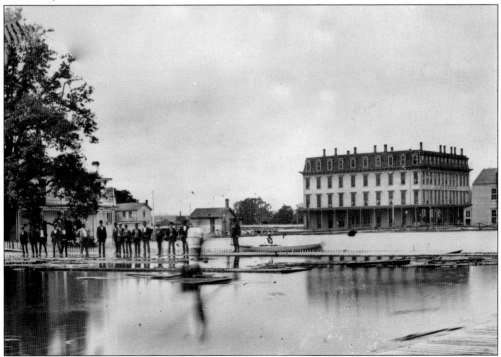

The Clarendon Hotel was located on NW First Street between Flanders and Glisan Streets. In this 1876 photograph, the hotel is surrounded by floodwaters from the nearby Willamette River. Portland's position as a river town exposed it to the seasonal fluctuations of the river, which it also depended upon for its livelihood. (Courtesy of the Oregon Historical Society.)

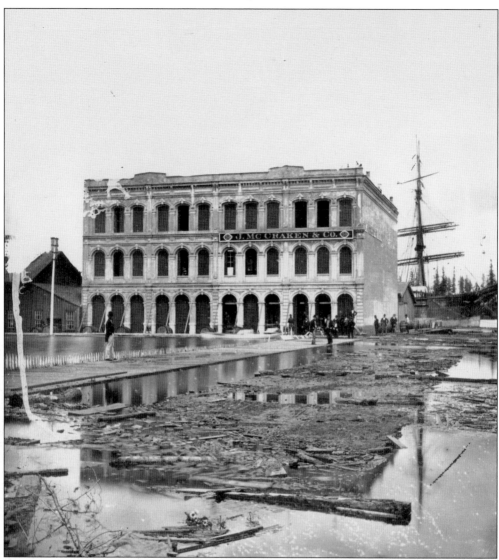

McCraken and Company was located at 64 N Front Street and Couch Street in 1876. Here, floodwater can be seen inundating developed areas of Portland. Building here, despite the risk of flooding, made shipping over water much easier. Note the close proximity of a sailing ship, docked on the river next to the building. (Courtesy of the Oregon Historical Society.)

Two

THE EARLY
INDUSTRIAL PERIOD

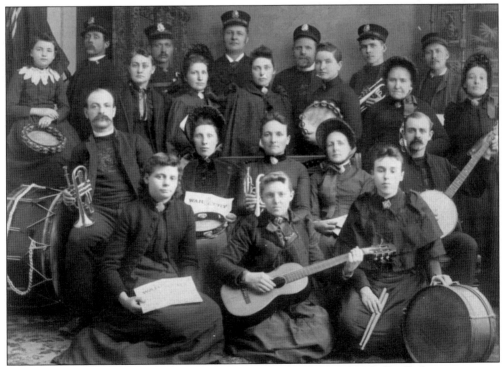

The Salvation Army Band is pictured here in 1890. Led by Capt. Mary Stillwell, the organization held its first outdoor service of music and preaching in October 1886 at SW Fifth Avenue and W Burnside Street. Not everyone was thriving in early Portland, and while they were not received well at first, the Salvationists eventually came to be accepted in the city as they worked to improve the lives of the poor.

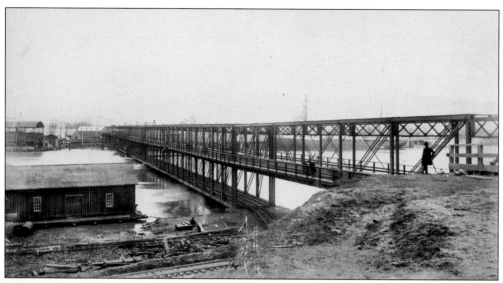

From the east bank of the Willamette River, the Steel Bridge is pictured here in 1890 with Couch's Addition to the west. This was the second bridge in Portland and was quite unique in that it accommodated both vehicles, such as wagons, and railroad traffic. It would only last for a few years, replaced by the current dual-level rail and vehicle bridge in 1912.

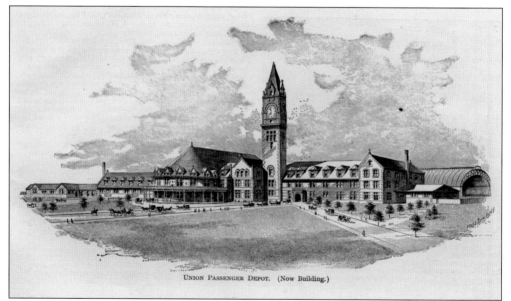

UNION PASSENGER DEPOT. (Now Building.)

Union Station is an iconic architectural feature in Portland today. However, the original plans for the station were much grander in 1890 than the final result. The clock tower was intended to be more ornate, and a railroad shed similar to those found in European railroad stations was also planned but never constructed.

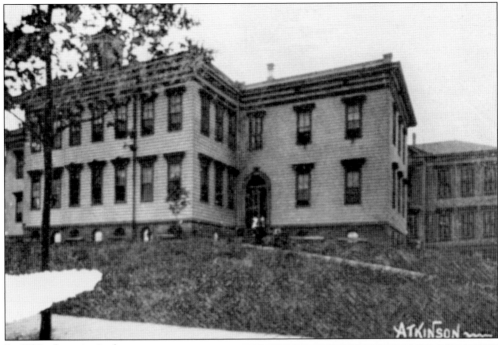

In 1892, the principal of Atkinson School was Ruth Rounds, who had been working there since 1888 and was responsible for 15 teachers. Built in 1867 and located on NW Tenth Avenue between Couch and Davis Streets, the school was originally known as North School. The name was changed to Atkinson in 1890 to honor George Atkinson, who advocated for public schools in the state and was a cofounder of Pacific University. In later years, most of its students were local children of Chinese or Japanese descent.

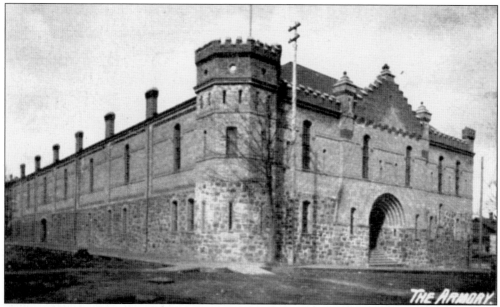

Pictured here in 1892, the armory building was constructed in 1891 for the Oregon National Guard. Its fortress-like facade would have provided people with a sense of security, given the problems of the day, which included anti-Chinese riots. It was also used for large public events for many years.

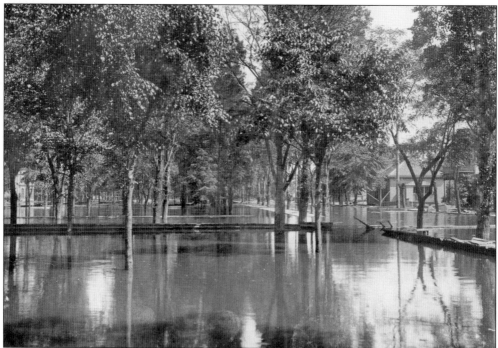

Flooding was a problem in Portland again in 1894. These floodwaters cover the Park Blocks, which are several blocks inland from the Willamette River. This situation was caused by a lack of any flood control on the Willamette and Columbia Rivers, especially when the snow melted in the Cascade Mountains during the spring.

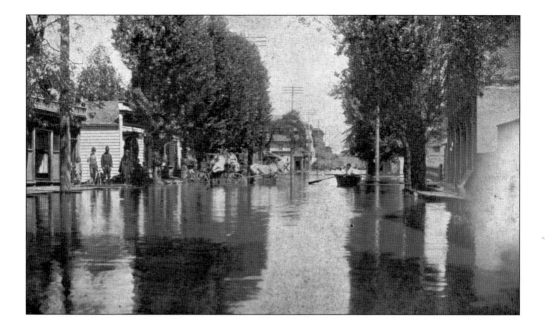

A street on the north end of town is inundated in the photograph above. The floodwaters are fairly deep, reaching up to the axle on the wagon's wheel. The photograph below of the 1894 flood shows a number of rowboats along the Park Blocks.

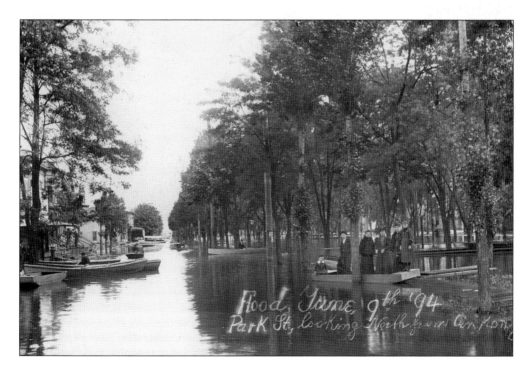

Flood, June 9th '94 Park St., looking North from Anton

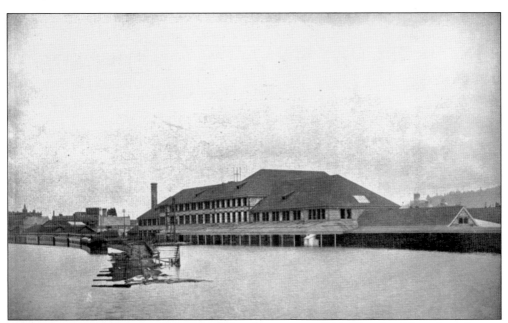

Union Station was under construction and under water in 1894. This should not have been a surprise, however, as the station was built where Couch Lake had recently been filled in. In fact, the nearby Willamette River was simply flooding its banks where it would have traditionally, except that human beings and their buildings were now in the way.

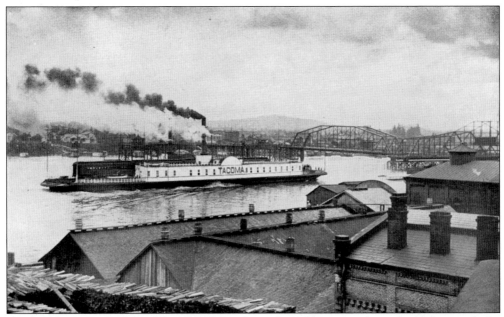

The buildings crowded along the waterfront of Couch's Addition are shown here along with the side-wheeler *Tacoma* as it approaches the Burnside Bridge during the 1894 flood. Note that the boat is carrying both passengers and railcars into Portland. Steamboats were quite prevalent on the Willamette and Columbia Rivers, especially before the arrival of the railroad.

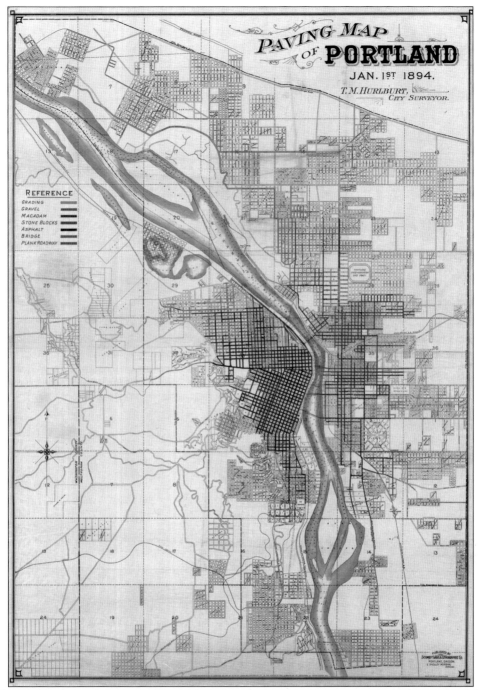

This 1894 color-coded map indicates the type of paving on city streets. A good portion of the Pearl District had some sort of paving, as can be seen in the darker tone of the streets, with much of Seventh Avenue from the train depot to NW Front Avenue and NW Northrup Street and from west of Eleventh to Seventh Avenues described as a "bridge" (an elevated structure rather than ground-level cobble or plank paving), most likely to deal with Couch Lake and its associated wetlands.

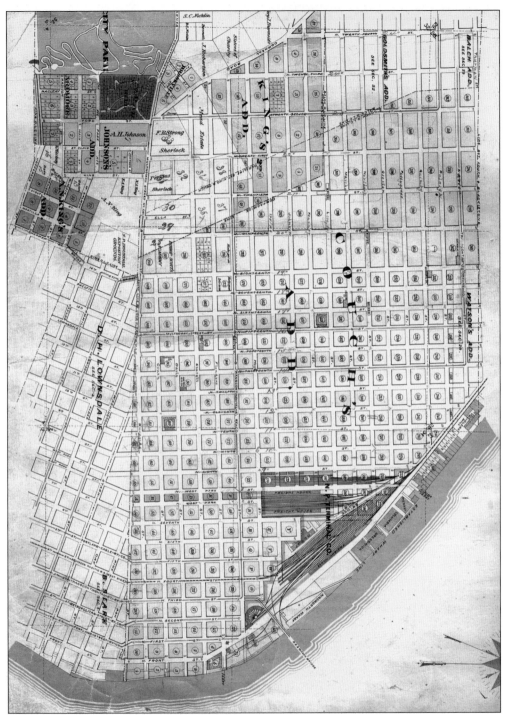

This map shows the entirety of Couch's Addition in the late 1800s. While the map is dated 1891, the area seems too developed for that period. However, by the late stages of the 1800s, much of the area was urbanized, and the railroad had become very prominent in the landscape. This is essentially the River District and Pearl District of the present day.

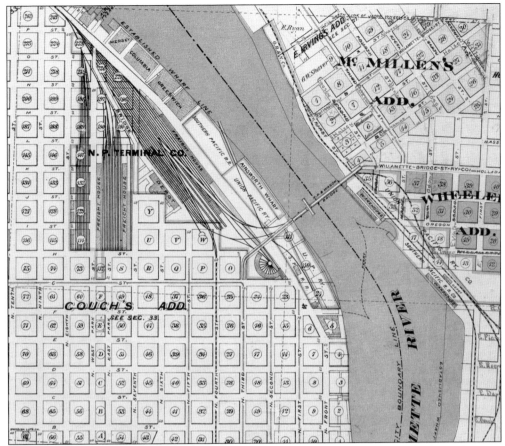

This 1891 map of Section 34 shows a close-up of the eastern portion of the Pearl District. Both the Southern Pacific and Union Pacific Railroads have wharves along the river, and the railroad network is extensive. A roundhouse is located just to the south of the Steel Bridge.

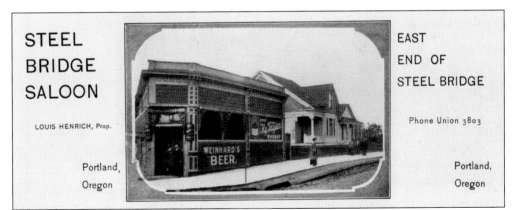

In 1905, the Steel Bridge Saloon was located just across the river from the industrial area, which would later become the Pearl District. The facade of the structure promotes a particular brand of whiskey and Portland's own Weinhard's Beer.

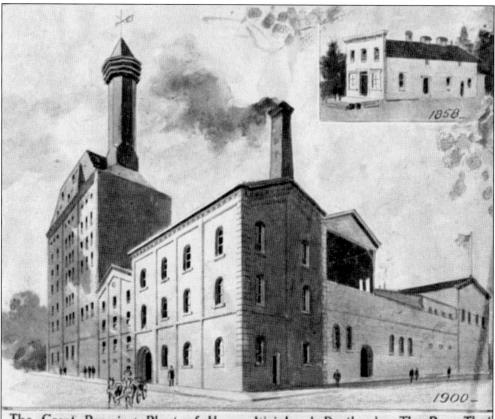

1858

1900

The Great Brewing Plant of Henry Weinhard, Portland. The Beer That Promises to Make Portland Famous. Weinhard's Beer is Today Sold in all Parts of the Pacific Northwest.

This is an image of the Henry Weinhard Brewery, located in Portland in 1900. The brewery would be active until the end of the 20th century, when it was sold to the Miller Brewing Company.

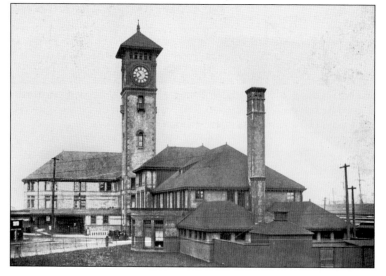

In 1904, Union Station was a brand new facility. However, future floods would try to reclaim the site.

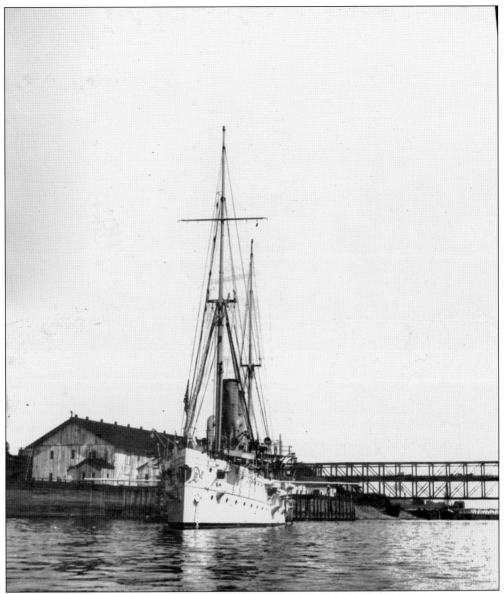

This military ship stood at anchor on the east bank of the Willamette River in 1905, just downstream from the original Steel Bridge. The bridge, constructed in 1888, can be seen in the background. It lacked the high towers that would be a part of its replacement a few years later.

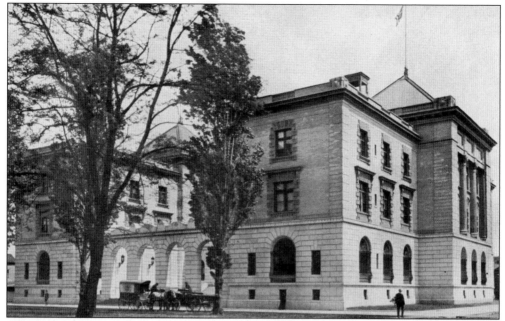

The US Customs House was six years old in 1904, located close to Union Station at NW Broadway and Everett Street. Local architect Edward Lazarus participated in this project; he would also work on the Vista House on the Historic Columbia River Highway. The US Customs Service moved to another location in 1968, and since that time, the US Army Corps of Engineers has been housed here.

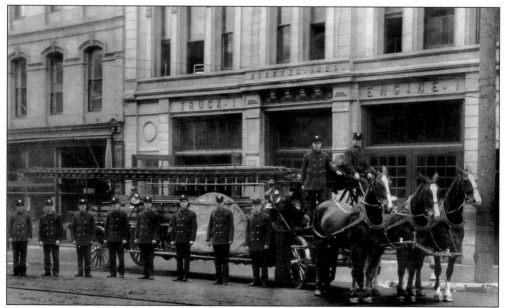

This is the crew of Fire Truck No. 1 in 1908 at its quarters, located at 720 SW Fourth Avenue. Vigilance Hook and Ladder One began in the volunteer era of the fire department at this location as well, operating between 1853 and 1883. This is quite a contrast from what the station, equipment, and crew looked like when the new Station No. 1 was built in 1950 at SW Front and Ankeny Streets.

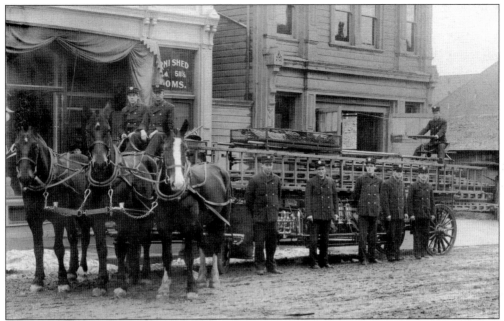

This is a photograph of horse-drawn fire truck No. 3 and its crew in 1909. The truck was housed at 1425 NW Glisan Street. While not in the photograph, dalmatians were a part of the team as well, running ahead of the horses to clear the way and keep them company at the fire station between emergency runs.

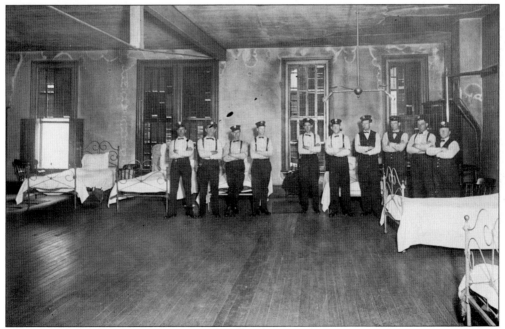

This is an image of the interior quarters of Station No. 3 at 1440 SW Washington Street, just off of Burnside Street. This station was active between 1884 and 1925. Note the sparse accommodations for the firefighters in 1913.

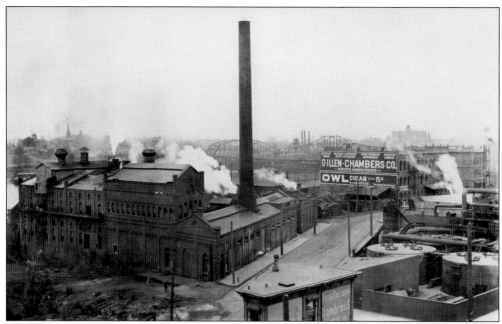

Pictured here in 1912 are NW Flanders Street and Front Avenue looking toward W Burnside Street. Note the large industrial plant and the billboard describing its fire retardant products. Fire protection was a must in factories, as were places to unwind after work, like the Boss Saloon, seen in the foreground.

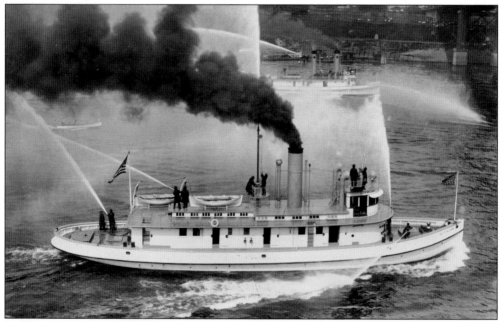

Two Portland Fire Department boats, *George Williams* and *David Campbell*, display their water-delivery capabilities on the Willamette River near the Broadway Bridge in 1913. The *George Williams* is in the foreground, and the *David Campbell* is in the background. Not long after, the *George Williams* had an equipment malfunction and was unable to provide any help to engines on the scene of a fire.

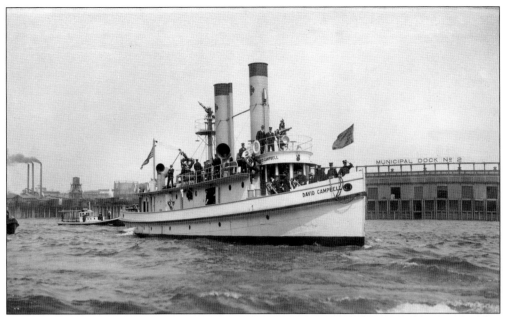

This is a close-up image of the Portland fireboat *David Campbell* in 1913. David Campbell was a popular fire chief who died fighting a fire in 1911. In July 1913, this boat was involved in a mishap at the Steel Bridge. While fighting a fire on the road deck, it ran into the bridge, sustaining some damage in the process. Fortunately, it and the *George Williams* performed well after these incidents until they were decommissioned in 1928.

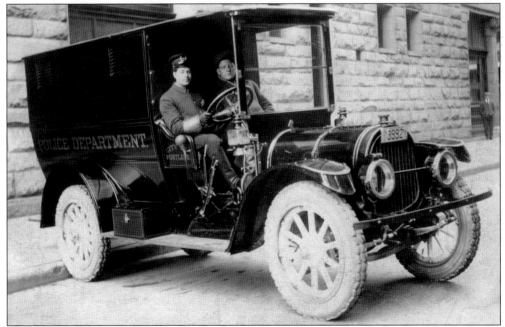

A few blocks north of what would become the Pearl District, the Portland Police Bureau's main headquarters was built in 1912 at 209 SW Oak Street, the year after this new paddy wagon went into service. The paddy wagon transported officers out to their various foot beats in the city and also transported prisoners to jail.

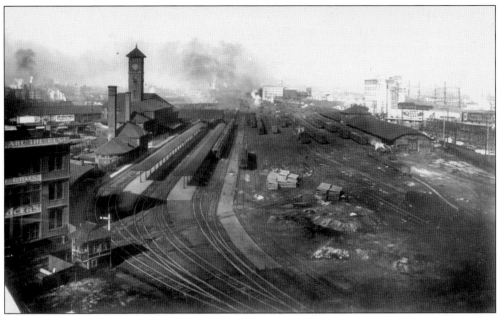

Union Station and the surrounding industrial development are pictured here around 1910. Note the thick smoke hanging in the air and the masts of sailing ships moored at docks along the river to the right. Some two decades earlier, people were recreating here at Couch Lake. (Courtesy of the Oregon Historical Society.)

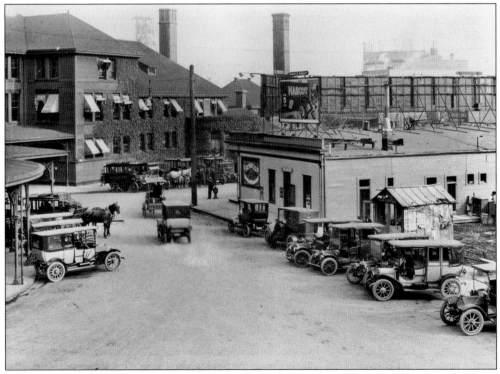

The passenger side of Union Station was also a busy place. Motor vehicles and horse and buggies are lined up in front of the station in 1913.

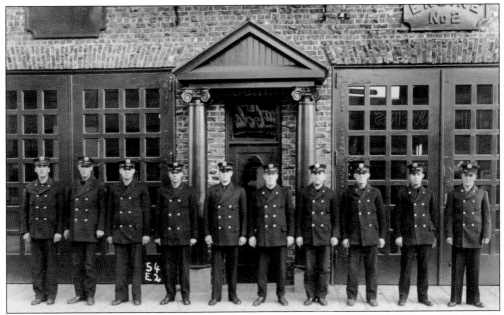

The Station No. 2 fire crew stands in front of its quarters at 510 NW Third Avenue in 1913. This station was operational between 1912 and 1950. At this time, the fire chief and others were well aware of Portland's vulnerability to fire all across the city, including the nearby warehouses and docks, where oil, creosote, and pitch were in abundant supply.

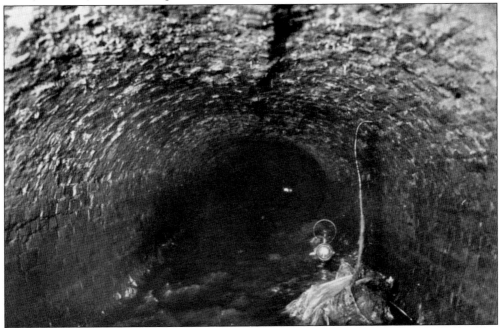

This is the interior of Tanner Creek Sewer in 1913. Tanner Creek used to flow out of the West Hills, through what is now the Highway 26 corridor, and across what would become the Pearl District of inner northwest Portland, making its way into Couch Lake and the Willamette River beyond. To make way for development, the stream was routed out of the way and into this underground sewer.

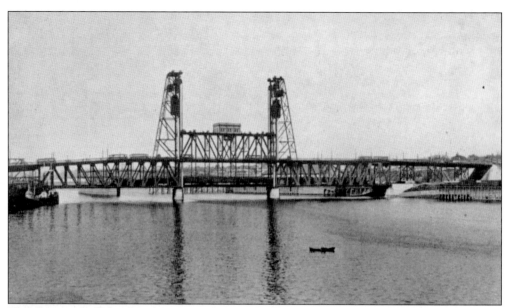

The three-year-old Steel Bridge appears here in 1915, with a train crossing on the lower deck and trolleys on the upper deck. As time passed, more and more motor vehicles joined the trolleys as they crossed the Willamette River. The bridge was constructed by the Union Pacific Railroad and is today the second oldest vertical-lift bridge in North America after the Hawthorne Bridge, which is also in Portland.

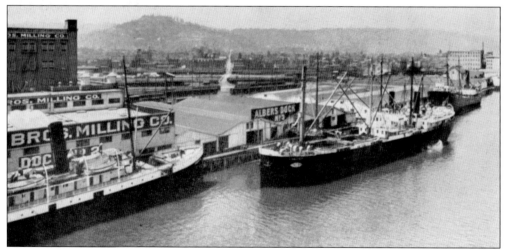

This is an image of the Albers Mill Dock just north of the Broadway Bridge in 1914. Not many years before, sailing ships crowded up along the shore of the Willamette River. Now, larger, more reliable steamships have taken their place.

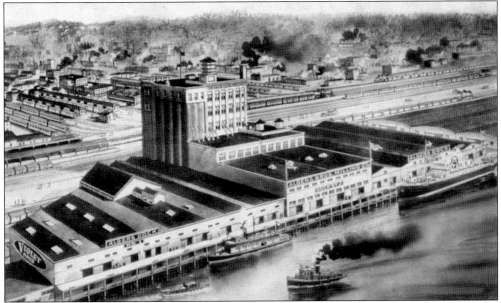

This 1915 rendition of the Albers Mill Dock and adjacent railroad yards displays thick smoke from trains and industrial operations in the area. Note that the artist all but ignores the West Hills and their natural vegetation, choosing to focus on the industrial might of the city instead.

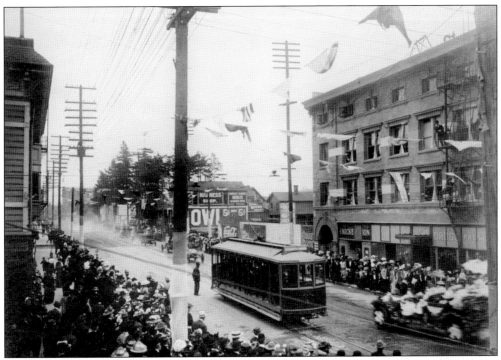

Portland was not all about work during the early 20th century. The Lewis and Clark Exposition was held at Guilds Lake north of the Pearl District in 1905, and the Rose Festival soon followed. The Rose Festival Parade, seen in this 1915 photograph taken from NW Sixth Avenue, began as an annual event in 1907.

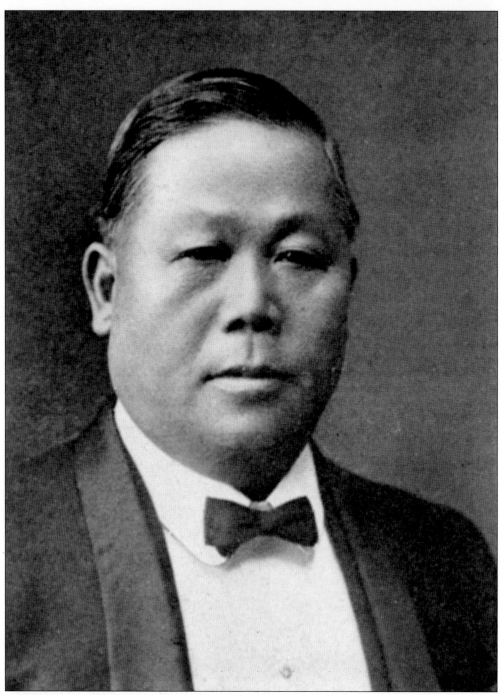

Pictured here in 1915, Seid Back was born in China in 1851 and moved to Portland when he was 17. He became a successful Chinese grocery merchant after working for the railroad. He also worked as a contractor, providing Chinese laborers for area railroads and canneries.

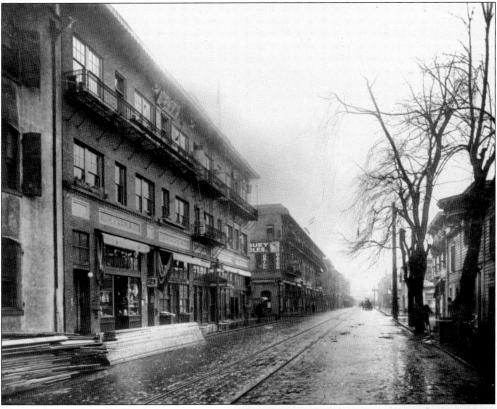

This photograph probably dates from the 1880s or 1890s. The image is of NW Fourth Avenue between Davis and Everett Streets in new Chinatown. Note that the buildings have been decorated with Chinese ornamentation and signs. (Courtesy of the Oregon Historical Society.)

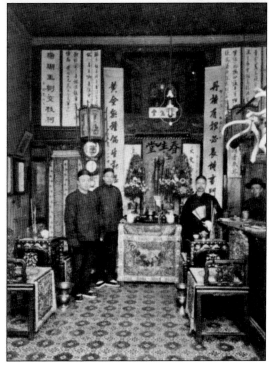

Here, men stand inside a Chinese drugstore in 1904. Chinese who were not employed elsewhere provided goods and services to the occupants of Chinatown in Portland, most of whom were men.

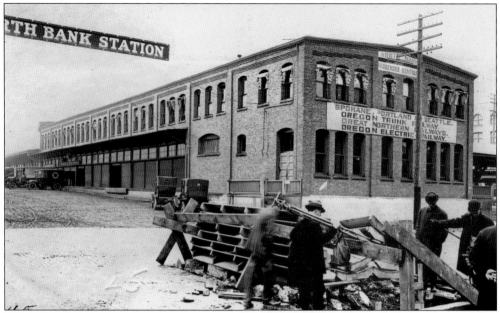

Men look at the sewer work being done across the street from the North Bank Passenger Station in 1917. As can be seen from the sign on that building at NW Eleventh Avenue and Hoyt Street, a number of railroads used this facility instead of Union Station because of a dispute between the station owner and the owner of the Spokane, Portland & Seattle (SP&S) Railroad.

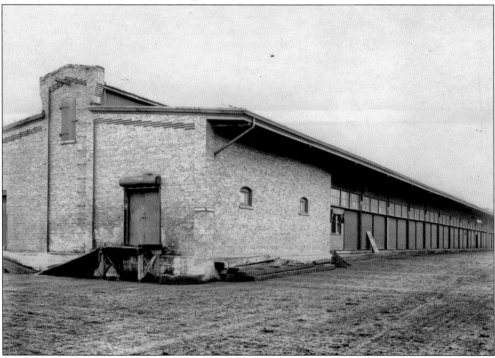

This is the North Bank storage facility at NW Eleventh Avenue and Hoyt Street in 1917. It was owned by the SP&S Railroad, storing goods for short periods of time before they were shipped or picked up from this location.

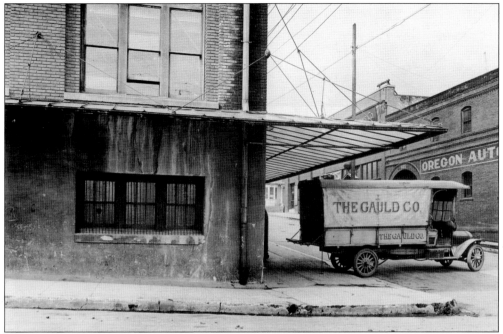

A delivery truck belonging to the Gauld Company is parked at NW Twelfth Avenue and NW Everett Street in 1917. While primitive by today's standards, the truck is a step up from horse-drawn vehicles, which were fading from the scene by this time.

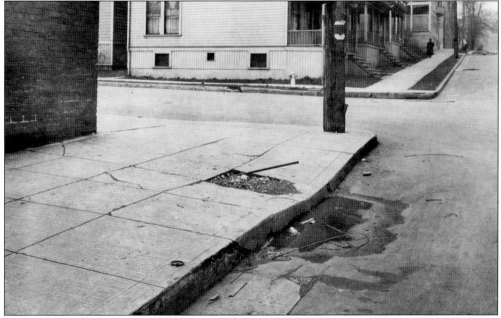

This 1917 photograph of the southeast corner of NW Fourteenth Avenue and Davis Street documents structural problems related to past sewer construction. Note the slumping of the curb and sidewalk near the corner from the failure of the underlying Tanner Creek Sewer. There is also a metal ring on the curb for securing horses like the ones still pulling some of the delivery wagons in the city.

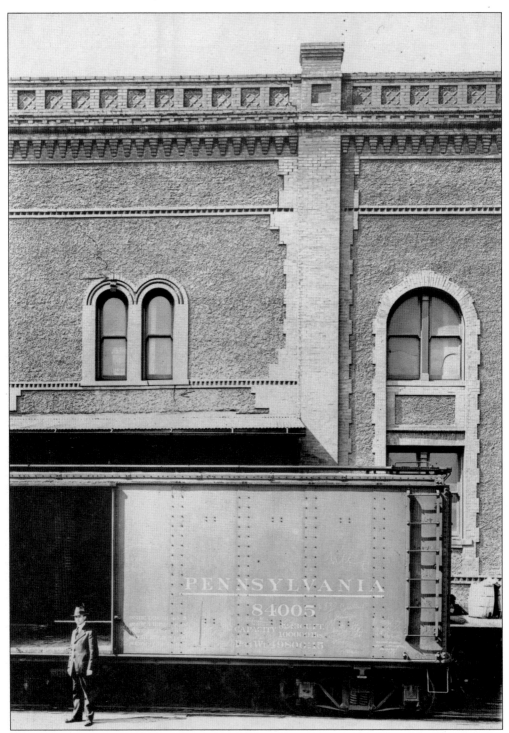

This is NW Ninth Avenue between Irving and Johnson Streets in 1917. The boxcar is either delivering goods to the facility or about to be filled with goods for delivery elsewhere. The crack in the building is from the failing Tanner Creek Sewer beneath, which had to be completely reconstructed.

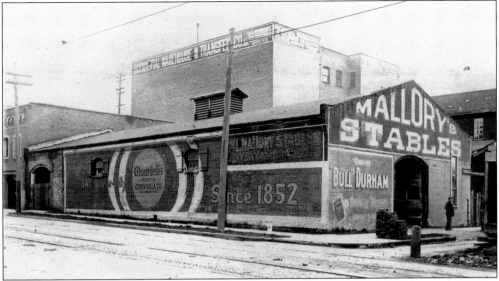

Horse stables were once a part of the urban landscape, as they were used to transport people and goods before motor vehicles were readily available. Here is the Mallory facility at NW Eleventh Avenue and Flanders Street in 1917.

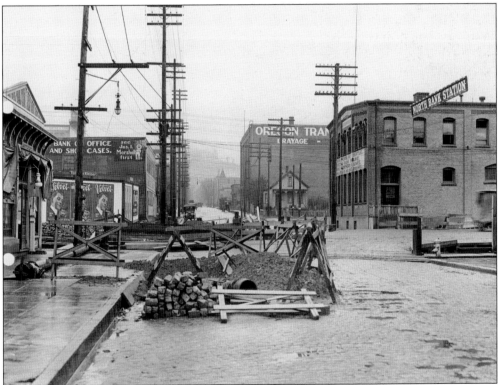

In this 1917 image of NW Hoyt Street taken from NW Tenth Avenue, Tanner Creek Sewer reconstruction can be seen in the street to the west. The North Bank Station and Oregon Transfer/Drayage are visible in the background. Drayage companies transported goods a short distance by motor vehicles that could handle large, heavy loads.

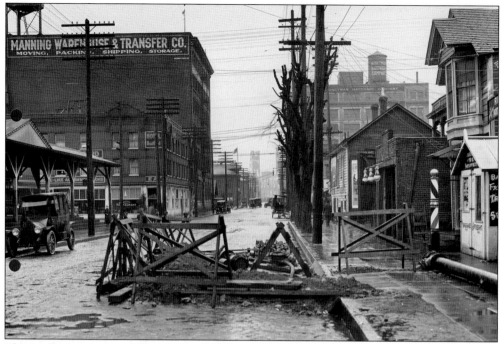

This is another image of Tanner Creek Sewer reconstruction. In this 1917 photograph of NW Hoyt Street near NW Tenth Avenue, the Steel Bridge can be seen in the distance to the east as well as the large Manning Warehouse in the mid-ground.

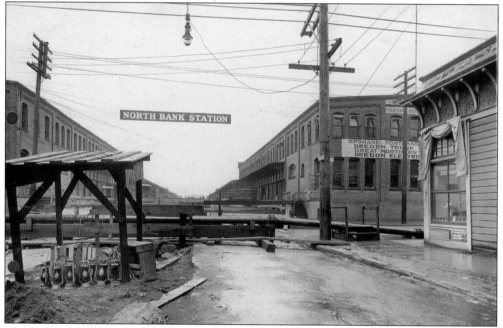

This image of Tanner Creek Sewer reconstruction shows Eleventh Avenue from just south of NW Hoyt Street in 1917. The North Bank Station is just across Hoyt Street. Note the lanterns stacked up for use under the lean-to and the large number of overhead electric power lines as oil lamps slowly give way to electric lights.

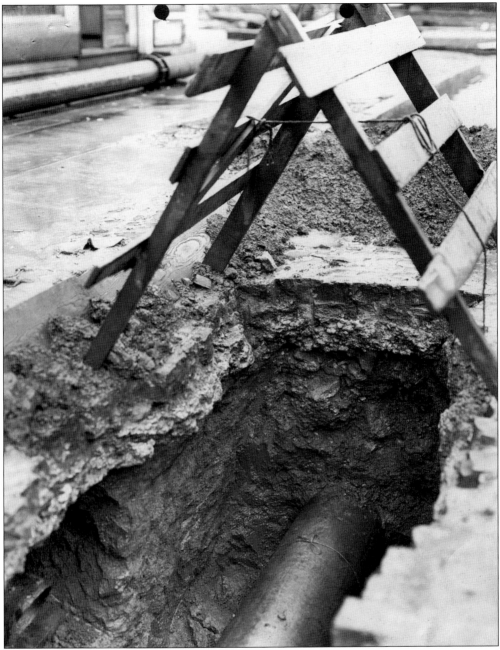

This is an image of the Tanner Creek Sewer pipe trench in 1917. The original sewer had followed the course of the stream, and when it began to fail, some of the overlying buildings were damaged, as seen in some of the earlier photographs. The replacement sewer avoided those problems by following city streets on its way to the river.

A Diamond Products horse-drawn grocery cart makes a delivery at the Wadhams and Kerr Brothers Building at NW Thirteenth Avenue and Davis Street in 1917. Here, street improvements have yet to cover all portions of the Pearl District.

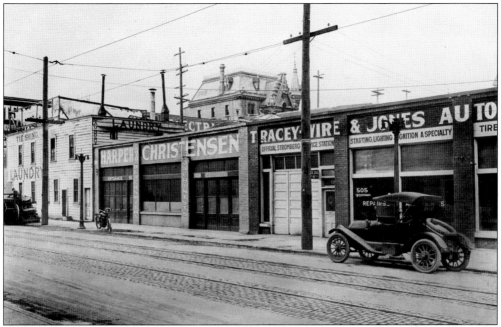

This is a photograph of the businesses associated with 505 and 511 W Burnside Street in 1917. With its close proximity to Chinatown and Japantown, it is not surprising to see a Chinese laundry at the far end of the block. In the rest of the block, there is an automotive shop, fairly common by then, and, a little more unique, a machinist and blacksmith shop.

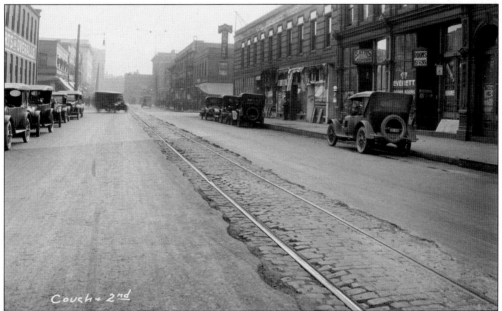

This 1921 photograph shows NW Second Avenue and Couch Street. Nearby, the industrial areas provided work for many of the men in the area, who most likely lived in hotels like the one pictured here. This hypothesis is reinforced by the laundry and showers advertised on buildings nearby. However, they would become venues for the poor in later years as industry and its employees departed for the suburbs.

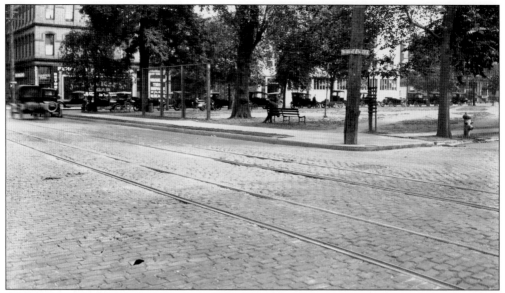

A man sits in the North Park Blocks at NW Park Avenue and Glisan Street in 1921. The Park Blocks were supposed to be an unbroken set of city blocks maintained as open park space from today's Portland State University in the south to NW Glisan Street in the north. Unfortunately, a few of the blocks were developed before the plan was completed, so that now, there are two groups of blocks called the North and South Park Blocks.

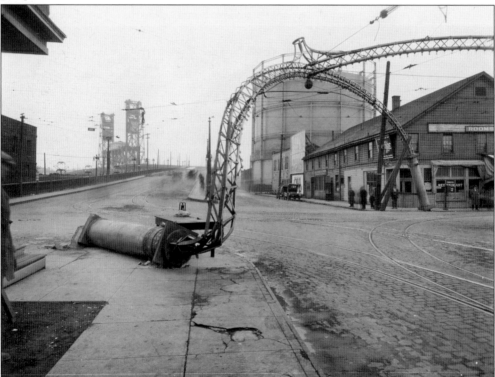

An ornate arched streetlight has been damaged by a traffic accident at NW Glisan Street at the foot of the Steel Bridge in 1920.

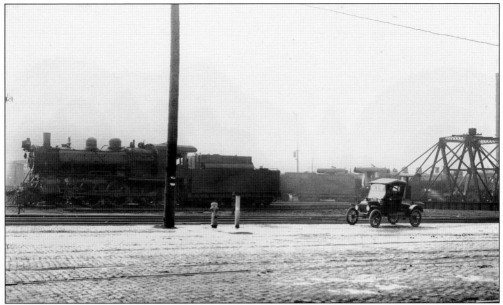

Two freight engines are pictured here along NW Front Avenue north of the Steel Bridge in 1917. This was the location where the Tanner Creek Sewer was scheduled to cross Front Avenue on its way to the Willamette River.

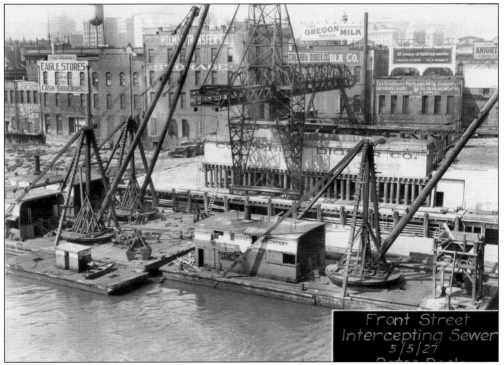

This was the Bates Dock, located on the south side of the Burnside Bridge in 1927, just before construction on the Front Avenue Interceptor Sewer began. At that time, buildings and docks along the waterfront blocked access to the river. Unfortunately, the later Harbor Drive Highway opened up the area but still hindered people's access to the Willamette River.

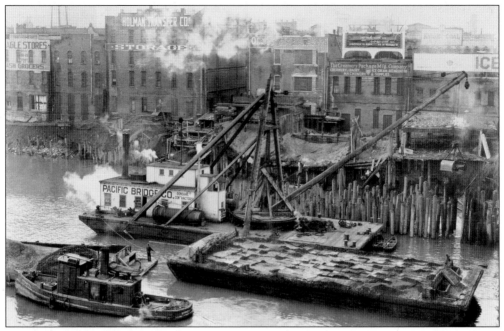

This 1928 photograph shows the Bates Dock being removed. The new sewer system that replaced it was designed to divert sewage from flowing directly under the docks and into the river and collect it in a sewer running along that riverbank behind a new river wall leading to a pumping station. That station would be used to pump the sewage into the river when the flow was low.

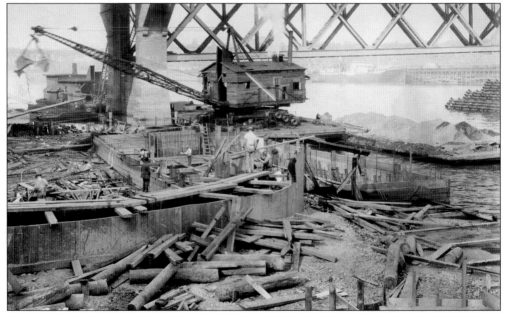

The new pumping station was under construction on the south side of the Burnside Bridge in 1928. By the late 1920s, however, people were again avoiding the river because of the sewage being dumped into it by this station. Due to funding issues, it would not be until 1952 that a sewage treatment plant was built in North Portland, and sewage from this plant was pumped over to it for treatment.

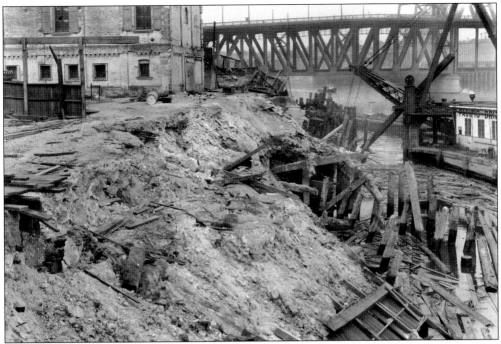

In this 1928 photograph, work on the Front Avenue Interceptor Sewer has moved north of the Burnside Bridge, resulting in the destruction of many aging waterfront buildings. The Steel Bridge can be seen in the background.

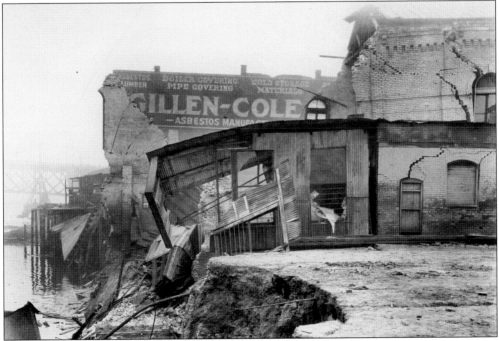

As the summer of 1928 wore on, work on the Front Avenue Interceptor Sewer project continued, removing the buildings on the waterfront near the Steel Bridge and transforming the river bank. The Burnside Bridge can be seen in the distance.

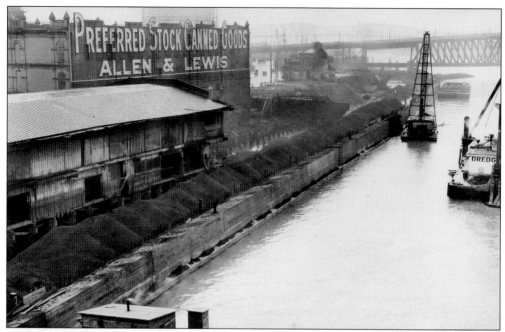

Work had progressed on the waterfront sewer project in 1928. The wall was beginning to take shape, and fill was being placed behind it. The wall was 18 feet thick at its base and 32 feet in height. The only known flood that had been higher was in 1894. Since then, the 1964 and 1996 floods have come close but have not exceeded it.

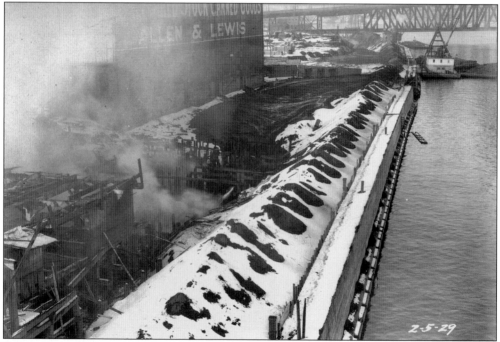

Facing the Steel Bridge, snow arrived before the completion of the river wall in the winter of 1929. While the large building west of the wall survived the initial construction, it was eventually removed.

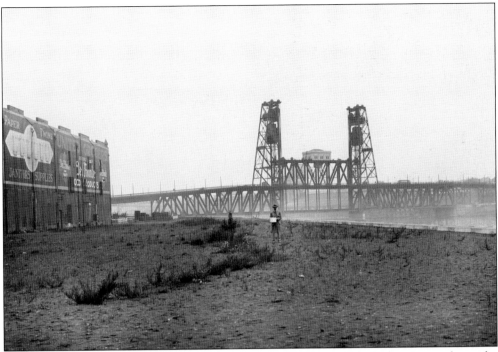

This 1929 photograph of the Steel Bridge and the harbor wall at NW Davis Street shows the dramatic changes that have occurred along the riverbank. The sewer has been improved, and a large amount of land is now available for redevelopment.

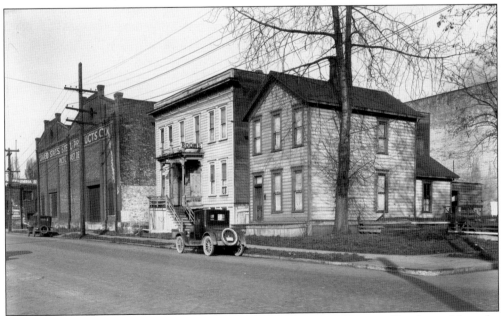

In 1925, NW Tenth Avenue and Glisan Street had an interesting set of land uses. Note the proximity of heavy industry to housing. The house closest to the US Steel building had rooms to rent and would be a convenient location for anyone working next door.

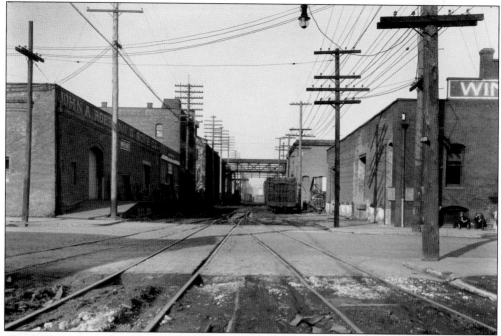

This 1928 photograph was taken at NW Thirteenth Avenue and Lovejoy Street before construction began on the Lovejoy Ramp to the Broadway Bridge. This ramp was built to carry motor vehicles over the numerous railroad tracks in the area. Rails and industry dominate this image of Thirteenth Avenue looking north.

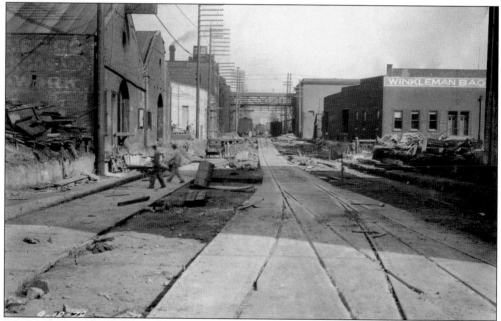

This is a 1928 photograph of Lovejoy Viaduct construction on NW Thirteenth Avenue. Note the buildings reduced to rubble to make way for the project. Street improvements are also being made on NW Thirteenth Avenue itself. Railroad cars and overhead connections to buildings on either side of the street are visible in the distance to the north.

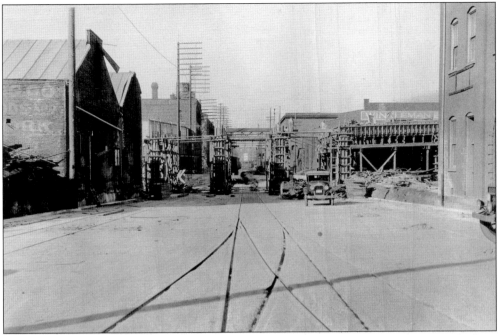

As 1928 progressed, the Lovejoy Viaduct began to take shape, as can be seen in this view looking north on NW Thirteenth Avenue.

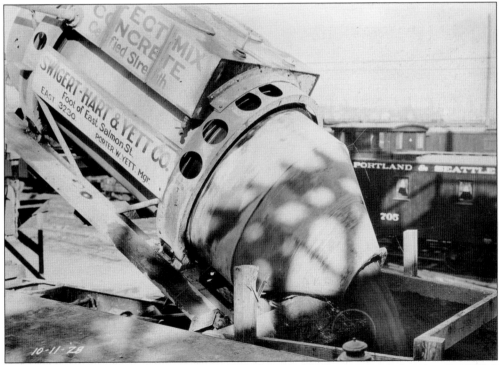

In 1928, a cement mixer pours concrete at the Lovejoy Viaduct construction site. An SP&S Railroad caboose can be seen in the background. Cabooses was once fixtures at the end of every freight train, but automation has made them obsolete.

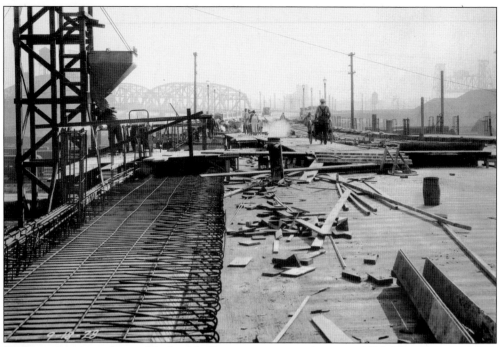

Construction up on the road deck of the Lovejoy ramp is underway in 1928. The rebar is in place for the concrete that will complete the sidewalks, which the man on the left appears to be preparing to pour. Looking on to the east, one can barely see the Broadway Bridge through the haze.

This late 1928 photograph reveals the completed Lovejoy Viaduct road deck. There is a lot of smoke in the area, and the ramp looks quite wide compared to the fairly small vehicles of the day.

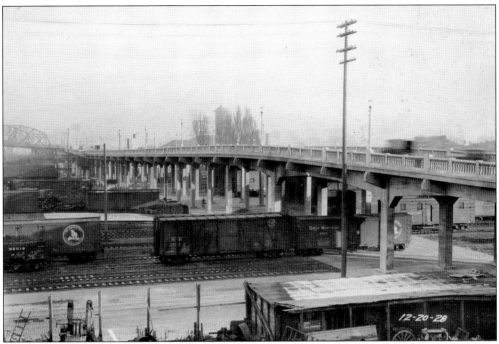

This December 1928 image of the new Lovejoy Viaduct reveals a portion of the Hoyt Street Yard below. This side image nicely shows the benefits of this new connection to the Broadway Bridge, which can be seen off to the east.

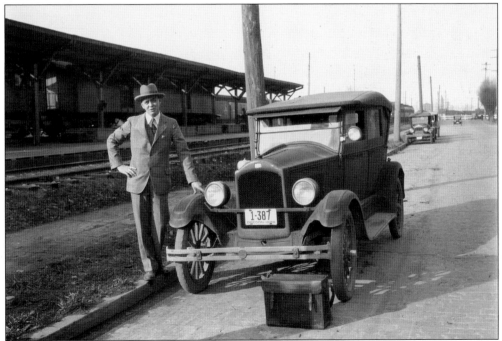

A passenger train is visible in the background of this 1928 photograph of NW Fourteenth Avenue and Lovejoy Street, but the man and his car symbolize how transportation was beginning to change.

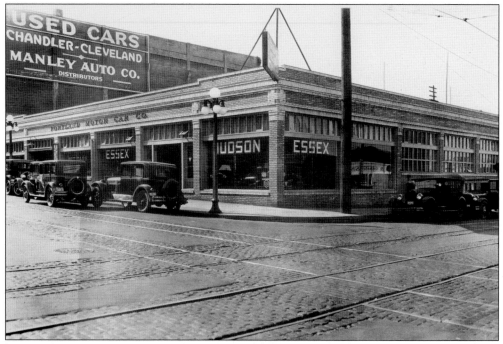

Despite the presence of trolley tracks in the street, this image of W Tenth Avenue and Burnside Street in 1927 is truly about automobiles, like the previous photograph. Automobile dealerships and cars parked on the street hint at the type of world that is to come.

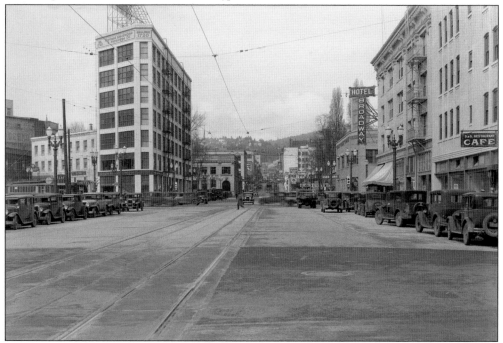

This photograph, taken in 1929 from Sixth Avenue, shows W Burnside Street looking to the west. The Broadway Hotel is located on the right side of the street, and the West Hills can be seen in the distance. Here too, the growing importance of the automobile to the city can be seen.

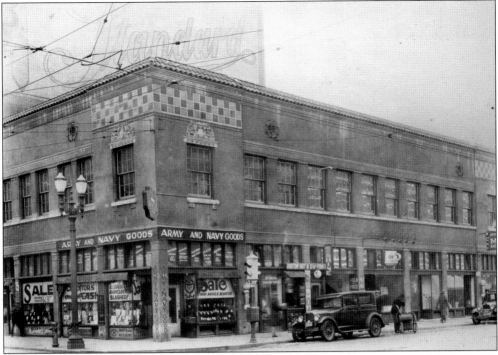

In this 1928 photograph, the Army and Navy Store is visible at Fifth Avenue and W Burnside Street. Note the standard-style streetlight, still in use today, and the man with a broom and garbage bag on the side of the road.

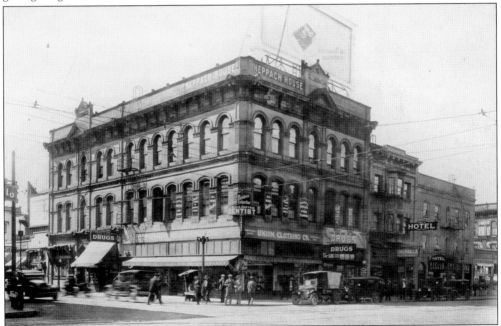

This is another example of a mixed set of urban activities including housing, dental services, a drugstore, and a clothing store at W Third Avenue and Burnside Street in 1928. Note the many pedestrians in this photograph.

A lumberyard was located at NW Front Avenue and Davis Street in 1929. In the background to the northwest, a Portland Gas Works storage tank advertises gas heat.

This 1929 view shows a pipe warehouse in the foreground image of NW Front and Everett Streets. It appears that the large building in the background to the left is being torn down.

NW Front Avenue and Flanders Street appear here in 1929. The Steel and Broadway Bridges are to the northeast in the background.

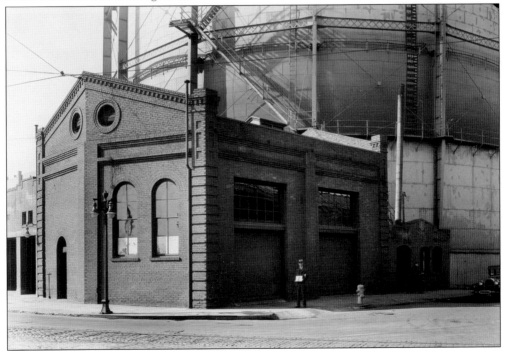

The Gas Works at NW Front Avenue and Glisan Street are shown here in 1929. The tank dominates the surrounding landscape near the Steel Bridge. Two similar structures were located near the Ross Island Bridge.

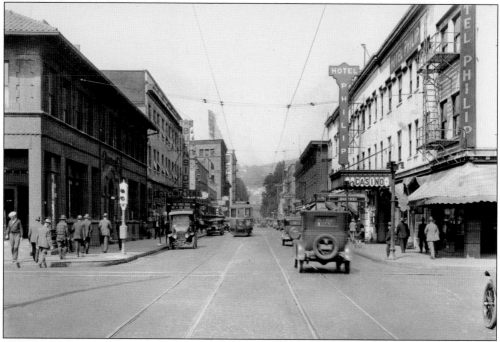

W Burnside Street at Fourth Avenue appears here in 1930 before the street was widened. Note the location of the trolley car tracks in the street. The buildings and sidewalks were built up against the roadway to allow for easy access for travelers from the streetcars to the businesses.

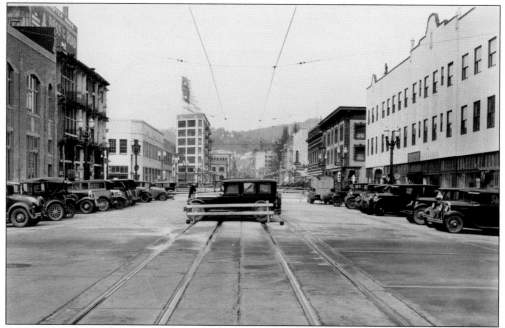

W Burnside Street is pictured here in 1930 after the street was widened. The roadway is much larger, and the focus is now on the parking. Some vehicles are even being parked over the trolley tracks themselves. The look and feel of the street has changed, and the street appears to be much less pedestrian friendly.

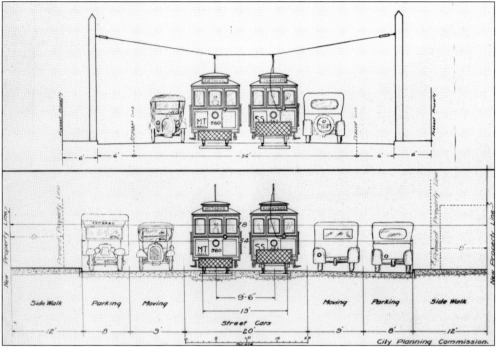

This 1932 cross-section diagram shows city standards for street construction where trolley service occurred. Note that in either scenario, the trolley tracks were always located in the center of the street. Vehicular movement and parking happened on either side of the tracks. This approach made trolley buses more attractive, as they could stop at the curb to pick up passengers. This also explains the patterns observed in the two previous photographs.

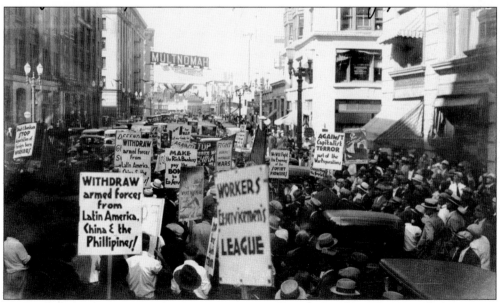

Protests have occurred in Portland in the past as well as the present. This was a large antiwar march on the street in front of the Japanese Consulate on SW Fourth Avenue in 1932. Large numbers of pedestrians stretch back toward Burnside Street, past the Multnomah Hotel.

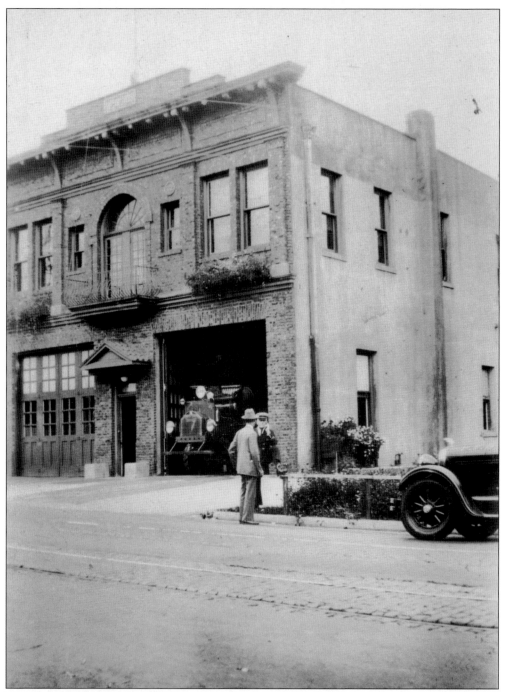

This is Fire Station No. 3 at NW Fifteenth Avenue and Glisan Street with an engine in the garage doorway in 1930. Automobiles replaced fire department horses in 1920 in Portland.

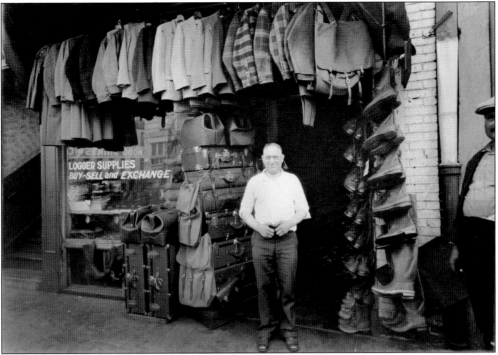

Pictured here in 1930, Alex Klonoff's Second Hand Store was located at 208 NW Couch Street. Note the sign advertising logger supplies in the window. Portland was still very much tied to the timber industry at that time and would be for many years to come.

This 1930 image shows NW Twelfth Avenue and Lovejoy Street looking south. Note the paving stone on Lovejoy Street, which appears to be Belgian block. NW Twelfth Street is completely unimproved and is primarily used for rail transport.

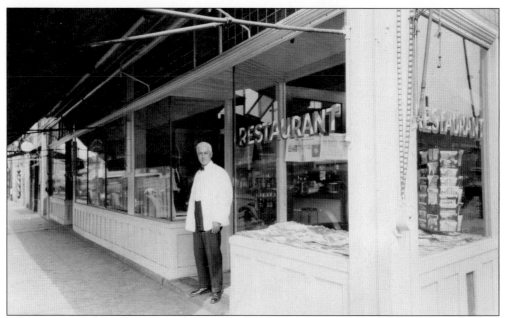

The Sixth Street Restaurant, at 460 NW Sixth Avenue in 1930, was just a short distance away from the Golden West Hotel on NW Everett Street, which was a major focal point of African American society from 1906 to 1931. A copy of the *Advocate* is visible in the window. It was published until 1933 and was the only newspaper in the state owned by African American entrepreneurs at the time of its demise.

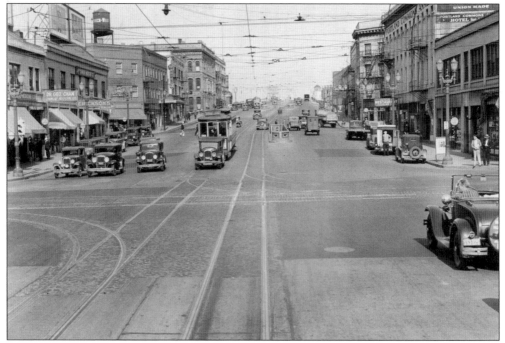

This is the vicinity of the west end of the Burnside Bridge in 1933. The area is filled with both pedestrians and vehicular traffic. A trolley, attached to one of the many sets of overhead wires, shares the lane with an automobile waiting at the traffic light.

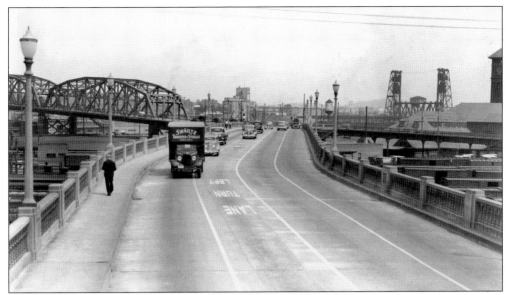

This 1938 image of the Lovejoy Ramp with the Broadway Bridge to the east clearly shows the industrial nature of the area. Note the Swartz Transfer and Storage van and the large numbers of railroad cars below the ramp.

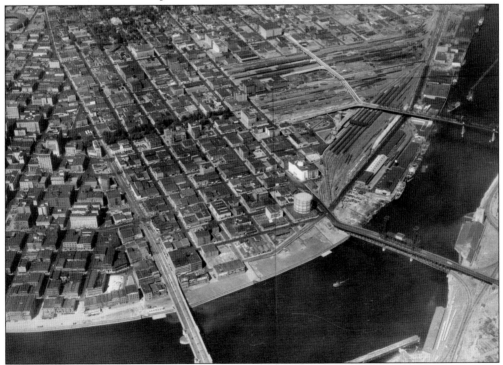

This 1938 aerial photograph shows the entire Pearl District. The urban industrial landscape contrasts starkly with the line of trees along the Parks Blocks in the mid-ground. This image underscores the importance of natural elements like trees, which soften the sharp edges of the rest of the area. The shoreline is also bustling with river traffic, and the river wall is clearly visible, running south from the Steel Bridge.

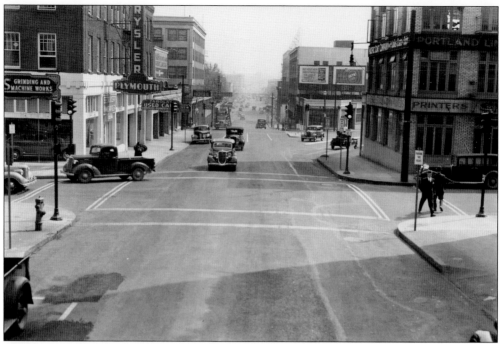

This hazy 1940 photograph shows a busy W Burnside Street at Eleventh Avenue looking east. Among the businesses, there is a printer and a machine works, but the trolley tracks are no longer present in the roadway.

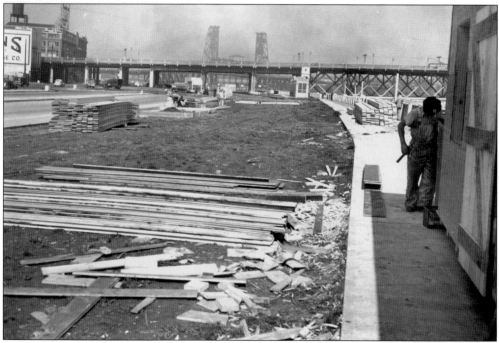

A man works at the Harbor Wall site in 1940. While a little difficult to see, the brand new White Satin sign is on top of the building to the left. It will eventually become the Portland Oregon sign of the present.

Three

THE POSTWAR
INDUSTRIAL ERA

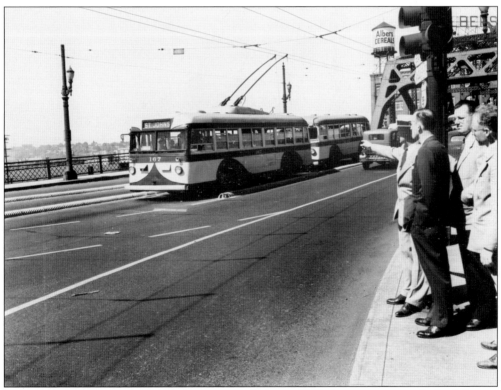

The west end of the Broadway Bridge is pictured here in 1947. A man points at the lead electric trolley bus, while the one behind it appears to be a standard fuel-driven model. Trolley buses were popular with the public at the time but would be completely removed from service by 1958.

City workers prepare for an impending flood in late May 1948. Sandbags were used along the river wall, which was called the "seawall" by many people in the city at that time.

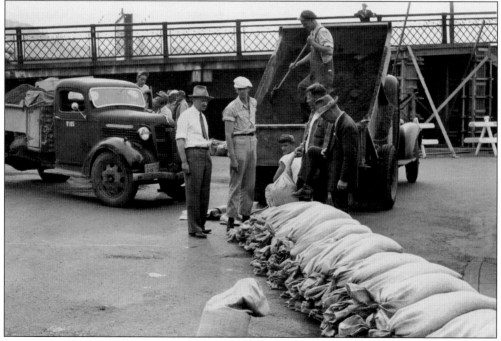

In late May 1948, city crews create a temporary dike for the expected floodwaters on NW Irving Street at Union Station. The Broadway Bridge Ramp from NW Broadway is behind them.

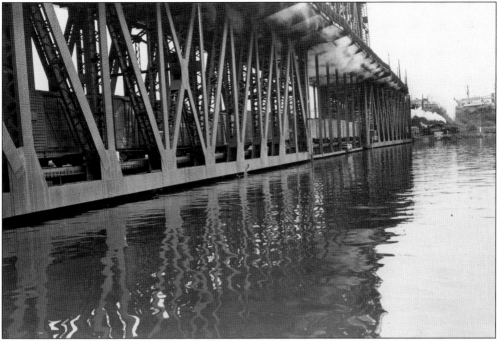

In late May 1948, a steam locomotive–led freight train rolls across the lower deck of the Steel Bridge, just above the floodwaters of the Willamette River. That deck is normally 26 feet above the river. The rising waters will soon be high enough to disrupt activities beyond the riverbank.

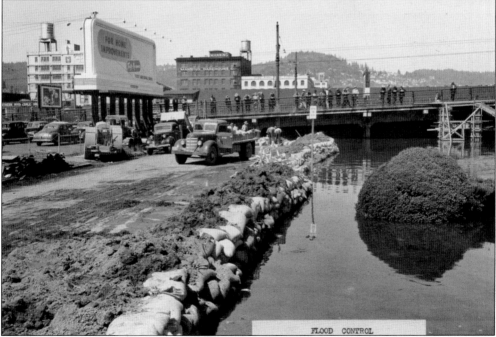

Pictured here is the temporary dike at NW Irving Street after the floodwater has arrived in 1948. A number of people are up on the Broadway Bridge Ramp from NW Broadway, photographing the water as city crews continue to work on the dike.

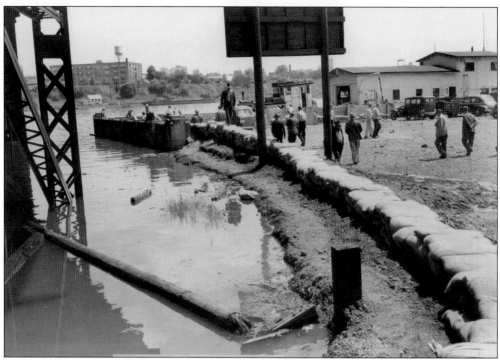

A temporary dike leads west from the seawall along the base of the Steel Bridge in 1948. Water has risen to the top of the bank as a number of people walk by, and a tugboat rides high along the wall.

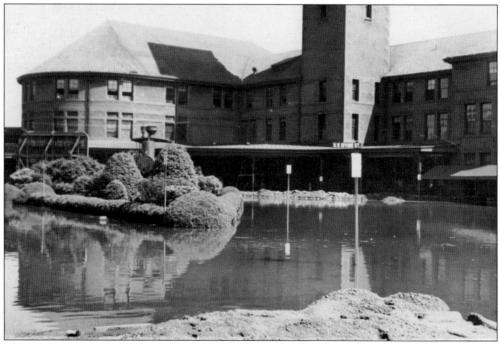

This 1948 photograph shows the front of a flooded Union Station. While inconvenient to travelers, this is not too terribly surprising, as this area was once covered by Couch Lake.

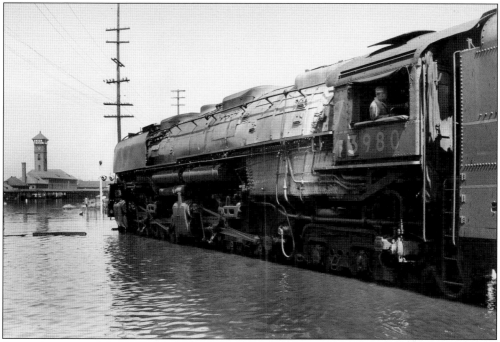

In another view of the 1948 flood, the railroad yard in the vicinity of Union Station is covered by the Willamette River as Union Pacific Engine 3980 sits at the waterlogged crossing on NW Front Avenue at the Steel Bridge.

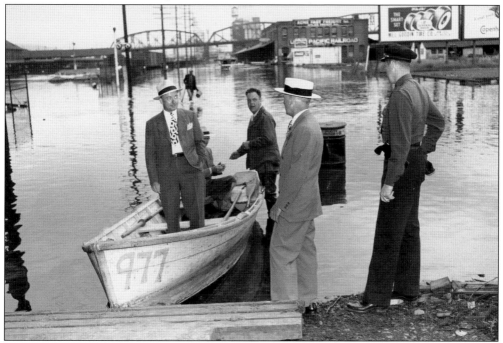

This June 1948 photograph shows NW Front Avenue just north of the Steel Bridge. A city commissioner stands in the boat, while a Portland police officer is standing on the far right. Note the extensive area that is under water at this point.

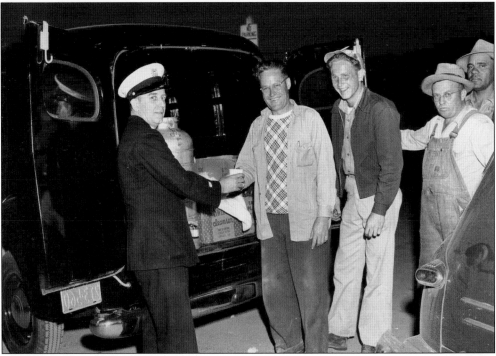

One evening in early June 1948, a Coast Guard officer serves coffee to city workers taking a break from their efforts to deal with the flood.

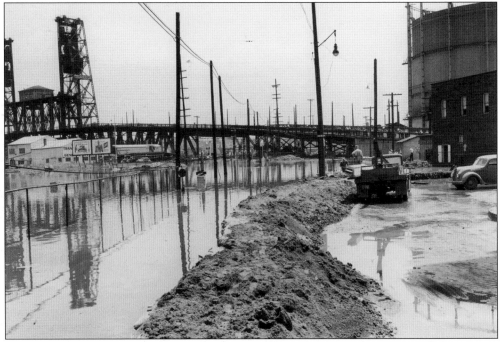

This 1948 image shows the temporary flood-control dike at NW Fourth Avenue and Hoyt Street, with the Steel Bridge and the river to the east. The main railroad tracks leading from the Steel Bridge into the Union Station Yard are completely covered.

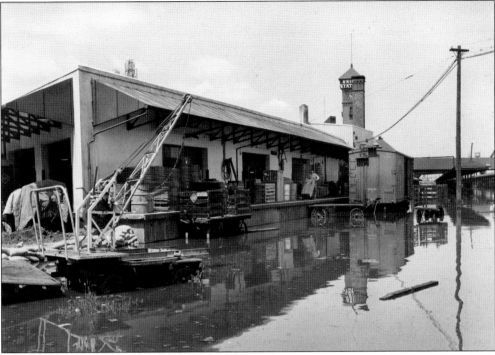

The American Express Building just south of Union Station is flooded in 1948. This image clearly underscores the disruption to shipping caused by these natural events.

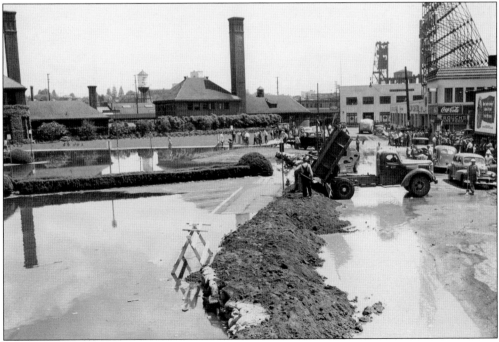

This 1948 photograph shows NW Irving Street looking to the east. Union Station is to the left behind the flood control dike, while water is being kept from spreading into the rest of the city to the right. Note the large crowds across from the station observing the scene.

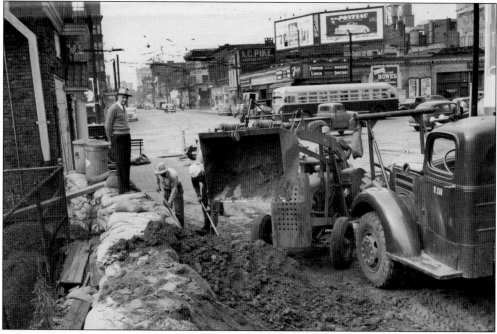

In June 1948, city workers are busy cleaning up sand and sandbags after the flood at NW Third Avenue and Glisan Street. Traffic passes by behind them, including a gas-powered city bus.

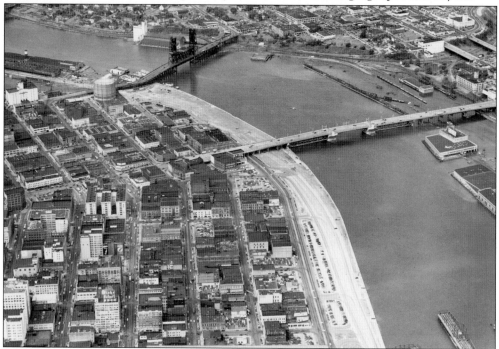

This 1948 aerial photograph of the waterfront north and south of the Burnside Bridge shows the river wall in place of the old docks and wharves. The empty land next to the river was soon turned into part of the Highway 99 system, known as Harbor Drive, which later became Waterfront Park.

ORDINANCE No. 91214

An Ordinance amending the Police Code by adding a new
section relating to discrimination in certain places
and by certain types of business on account of race,
color, religion or national origin.

The City of Portland does ordain as follows:

Section 1. The Council finds that to further the objec-
tives contained in the Constitution of the United States and
the Constitution of the State of Oregon, and as an exercise
of the police power of the City of Portland, provision
should be made against discrimination on account of race,
color or religion in public or quasi-public places; that in
the interest of public health and as an exercise of the
police power of the City such regulations should also extend
to hospitals, ambulances, mortuaries, funeral conveyances
and cemeteries; that civil rights of all persons within the
police jurisdiction of the City should be safeguarded as
provided herein; now, therefore, Article 27 of Ordinance
No. 76339 (Police Code) hereby is amended by adding
thereto a new section to be numbered, entitled and to read
as follows:

Section 16-2703. PLACES OF PUBLIC ACCOMMODATION
SHALL BE OPENED TO ALL PERSONS WITHOUT DISCRIMINATION
BECAUSE OF RACE, COLOR, RELIGION, ANCESTRY OR NATIONAL
ORIGIN. All persons within the police jurisdiction of
the City of Portland shall be entitled to full and
equal accommodation, advantages, facilities and privi-
leges in all places or businesses offering or holding
out services or facilities to the general public,
including but not limited to hotels, lodging houses and
rooming houses as defined in the License and Business
Code of the City of Portland, restaurants or other
places where food or drink are offered to the public
generally for consumption upon the premises, theaters
or other places of amusement, public transportation
carriers, public facilities in office buildings or
other places open to the general public, retail stores,
hospitals, ambulances, mortuaries, funeral conveyances
and cemeteries. It shall be unlawful for the owner,
lessee, manager, or proprietor of a place of business
within the City offering or holding itself out as af-
fording services or facilities to the general public

This is a reproduction of city ordinance 91214, enacted in 1950. It prohibited discrimination
against people based upon race, color, religion, ancestry, or national origin in all places offering
services to the public.

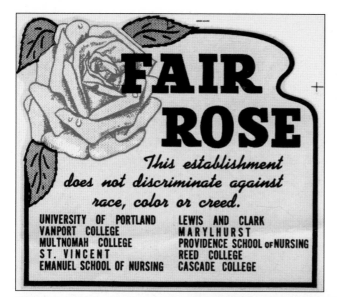

This is an antidiscrimination decal from 1950 called the Fair Rose. City businesses displaying this rose indicated to the public that they did not discriminate against anyone because of their race or religious beliefs. This would have been a very relevant symbol in the culturally diverse Pearl District.

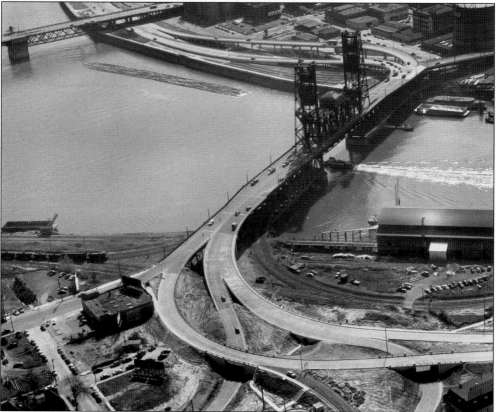

A 1952 aerial image of the Steel Bridge includes the new Harbor Drive/Highway 99 along the west bank of the Willamette River. The lower railroad deck has been raised to allow a vessel to pass by southbound on the river while the upper car deck remains open to traffic. A smaller vessel is pulling a log raft the in the opposite direction. Wood products were still a big industry in Portland at this time.

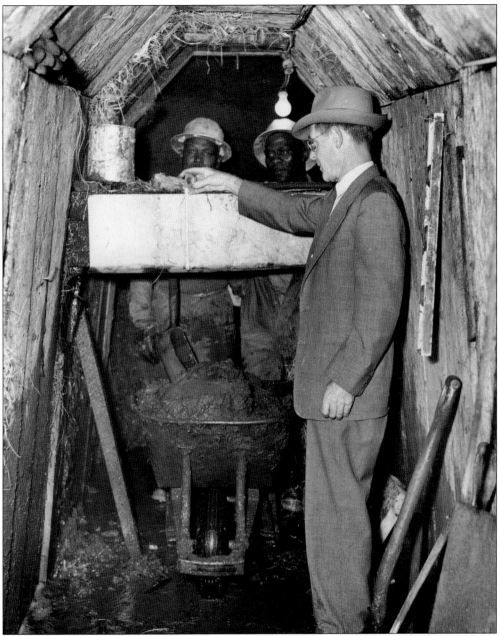

In this 1953 photograph, workers appear inside a utility tunnel at NW Fourteenth Avenue and NW Quimby Street. Note that the man in the suit is measuring the width of the beam and unlike the two workers in the background does not seem properly dressed for the occasion.

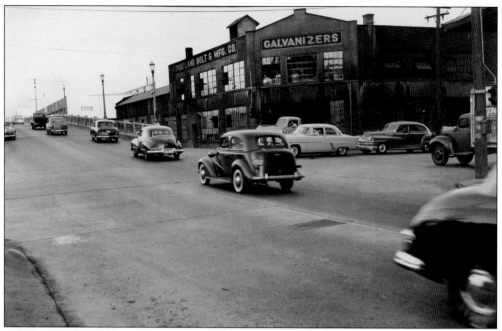

Heavy vehicular traffic is pictured here at NW Fourteenth Avenue and Lovejoy Street in 1952. A large industrial facility involved in the manufacture of bolts and the galvanizing of iron and steel products is located on the southeast corner. The Marshall Wells Warehouse is located just to the right of this photograph on the southwest corner.

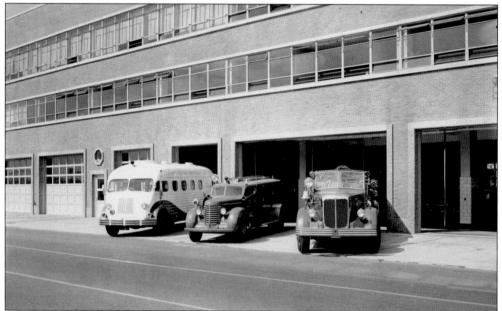

The Central Fire Station is pictured here five years after its opening in 1950. It is located just south of W Burnside Street on NW Front Avenue and provides fire service to much of downtown and the Pearl District. The fire equipment includes, from left to right, a 1936 Federal, a 1939 Kenworth, and a 1948 Mack. This is a world away from the original headquarters and its horse-drawn equipment.

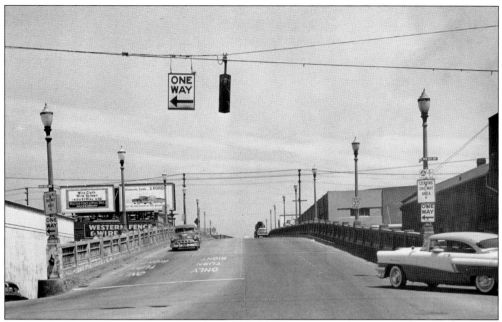

This 1956 image, taken from NW Fourteenth Avenue, shows the Lovejoy Viaduct to the east. Note that while the ramp is as large as it was when it was first constructed, the need for more lanes and the increased size of motor vehicles combine to make it appear to be a much narrower thoroughfare.

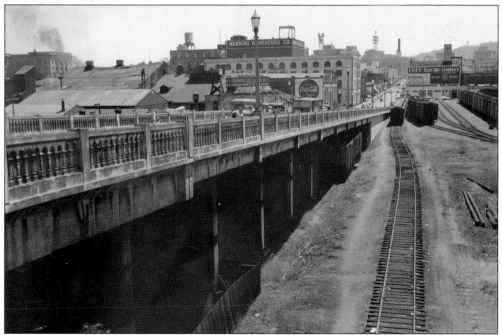

A 1956 image of the NW Tenth Avenue Ramp from the Lovejoy Viaduct shows downtown Portland to the south. Railroad tracks dead end at NW Hoyt Street, and a variety of industry is visible here, including an electrical company, hardware company, steel casting plant, hardware wholesale facility, and large warehouse.

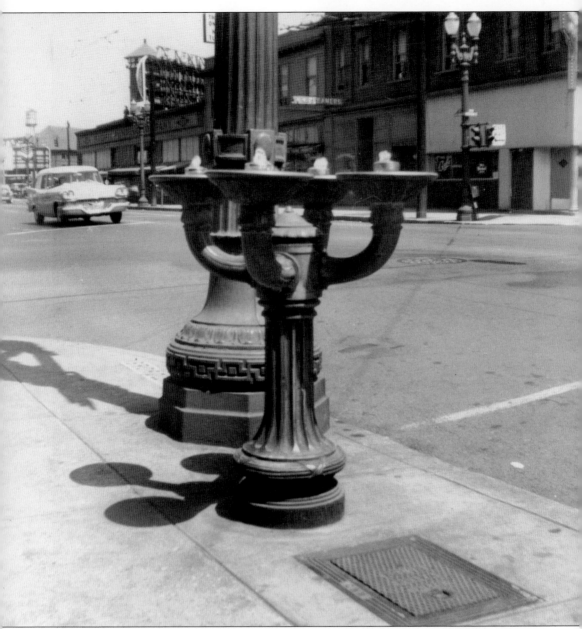

A city water fountain, known as a Benson Bubbler, was located on the corner of NW Broadway and NW Glisan Street in 1958. Simon Benson made his fortune in the timber industry and became a philanthropist upon his retirement. He believed that thirsty loggers would prefer a cool drink of water rather than alcohol when they came into town, so he donated the bubblers to the city.

A railroad worker is pictured in the railroad yard north of Union Station in the 1940s–1950s. Front Avenue is to the left, and the switch engine behind him appears to be coming out of the Hoyt Street Yard. (Courtesy of the Oregon Historical Society.)

An aerial 1959 photograph shows the rail and industrial activities in a portion of the Pearl District, including the docks on the Willamette River opposite the Union Station railroad yards. Note the freighter docked to the left of the Broadway Bridge. (Courtesy of the Oregon Historical Society.)

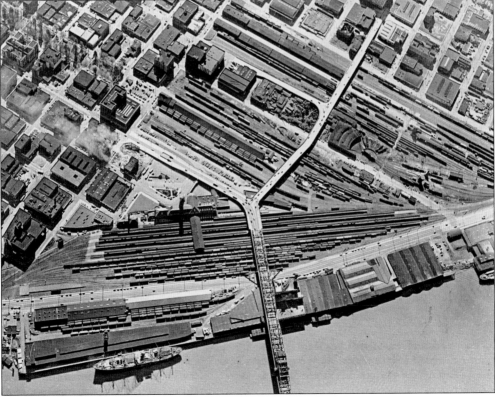

Large signs were a common part of the landscape in 1959. In this view from Broadway at Sixth Avenue, NW Irving Street is visible to the east. Union Station is out of sight to the left, and the black towers of the Steel Bridge are visible in the background beyond the Yellow Cab Company.

This 1961 photograph of the Lovejoy Ramp at NW Tenth Avenue and an SP&S passenger train car clearly shows why the viaduct was built. While in close proximity to one another, railcars and motor vehicles are separated and therefore smoothly operate without interfering with each other.

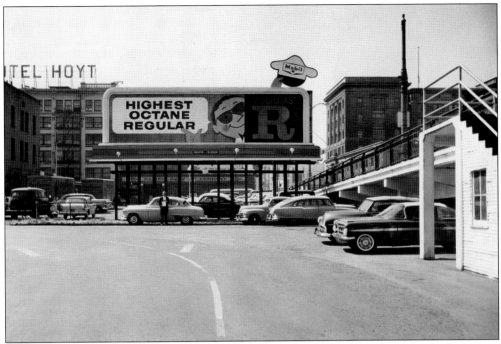

This image shows the Broadway Bridge Ramp from NW Broadway looking south adjacent to Union Station in 1959. Note the huge billboard for Mobil Gas, underscoring the importance of oil to this automobile-dominated landscape. The Hoyt Hotel is in the background on the left.

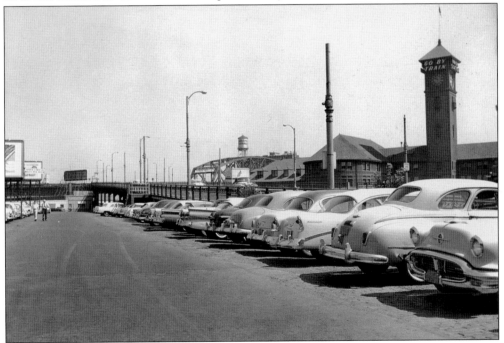

This 1959 photograph, taken from around Irving Street, shows the west side of the Broadway Bridge Ramp looking north. Union Station is across the street, but the full parking lot in the foreground demonstrates how important car travel had become.

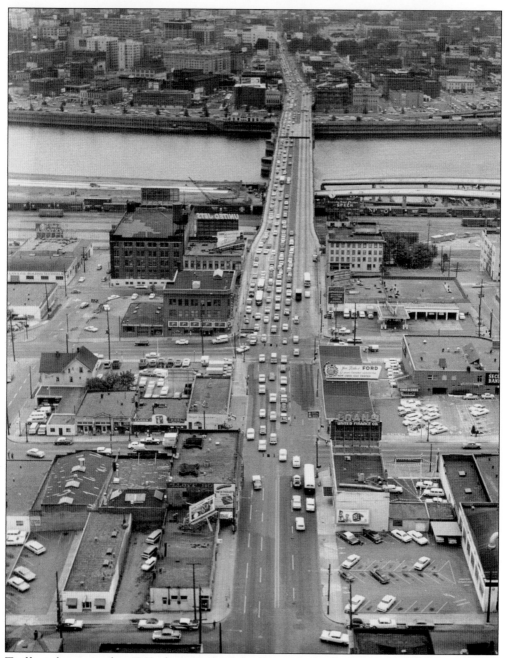

Traffic is heavy in this 1963 photograph of the Burnside Bridge across the Willamette River looking west. The Pearl District is off to the right, and Harbor Drive hugs the seawall on the far west side of the river. The river wall is clearly visible, as are public access points to small public docks along the wall. I-5 is under construction along the east bank of the river.

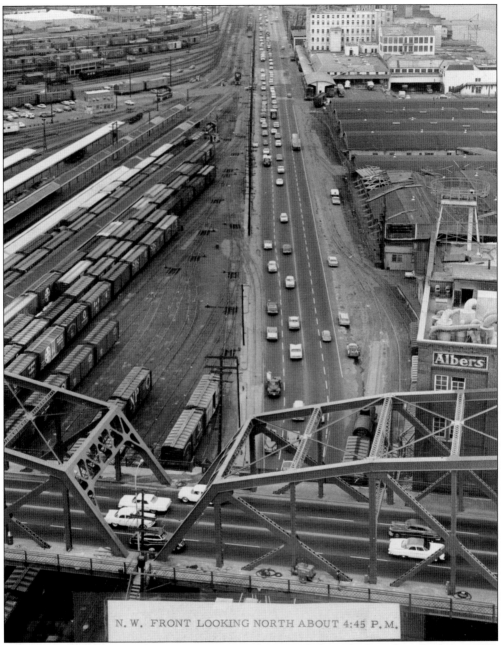

N. W. FRONT LOOKING NORTH ABOUT 4:45 P.M.

This is an aerial image of NW Front Avenue looking north from the Broadway Bridge in 1964. NW Front Avenue is filled with vehicles during rush hour. The Hoyt Street Yard to the left is busy and well maintained, and the riverbank to the right is covered with industrial facilities that are served by railroad spurs from the main yard.

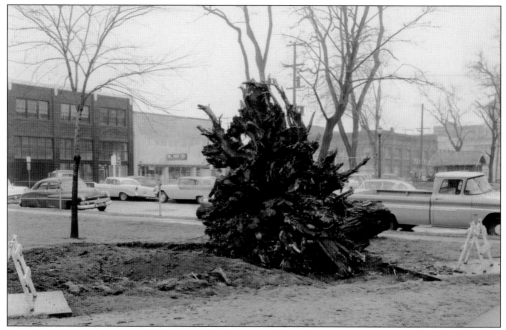

This photograph provides an example of the damage done in the October 1962 Columbus Day storm. Here, a large root system from a tree blown over during the storm in the North Park Blocks will eventually be removed by the city. Many large trees were lost in Portland as a result of this strong Pacific storm.

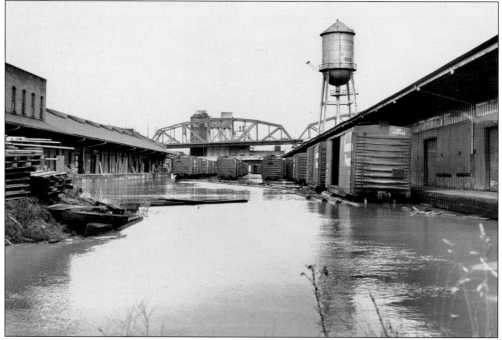

Another serious flood inundated portions of Portland in 1964. In this case, floodwaters invaded the Hoyt Street Yard, stranding a large number of boxcars in what was then an active industrial area. (Courtesy of the Oregon Historical Society.)

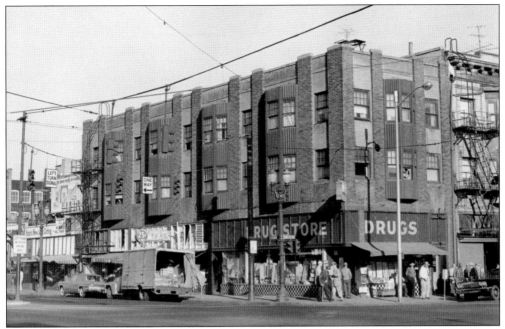

A drugstore was located on the northwest corner of NW Third Avenue and W Burnside Street in 1965. Note all of the pedestrian activity on the sidewalk and the housing in the building above the drugstore. This type of building came back into vogue in the Pearl District once planners realized that lively inner-city neighborhoods only exist where people live.

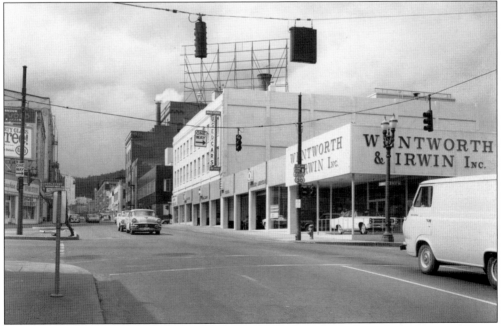

This 1967 image shows W Burnside Street at Tenth Avenue. A used car dealership is visible on the northwest corner of the intersection. This would become the home of Powell's Books in 1971. Now one of several locations, this main store covers the entire block and is reported to be the largest independent new and used bookstore in the world.

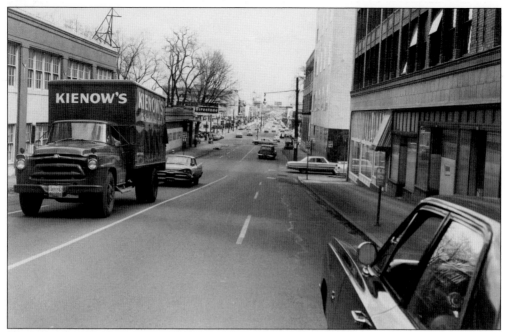

This photograph, taken from NW Ninth Avenue, shows W Burnside Street looking east in 1967. Note the Kienow's truck heading westbound on Burnside Street. Kienow's was a local grocery chain at that time in Portland. The trees of the North Park Blocks are visible on the left side of the photograph.

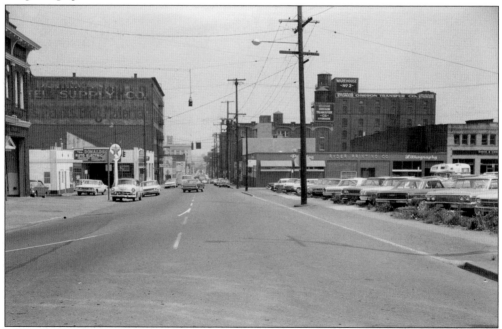

An industrial landscape is still very much in evidence on NW Glisan Street in this 1967 photograph taken from NW Fourteenth Avenue. Note the many faded signs on the large warehouse-style building on the left beyond the gas station and the still-active Oregon Transfer Company warehouse on the right.

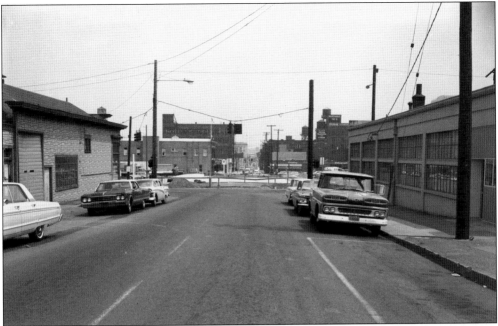

In this 1967 photograph looking east from NW Sixteenth Avenue on NW Glisan Street, the Glisan Street overpass is being built over the new I-405 freeway below. This freeway will add a loop around the west side of downtown, connecting up with I-5 via the Marquam and Fremont Bridges.

The Portland Fish Company is in operation near NW Fourth Avenue and Flanders Street in 1971. Note the crates of fish in the street on their way to being processed. Located west of the Steel Bridge, the area is also home to the NW Natural Gas offices, which has the oblong gas flame symbol on its roof.

This is another image of the Portland Fish Company on the south side of NW Flanders Street in 1971. Related industrial activities have spilled out onto the sidewalk. However, other uses are also visible—note the sign for a hotel on the building down the street.

In Chinatown in 1969, Chinese restaurants are visible along Fourth Avenue to the south from NW Fourth Avenue and NW Davis Street. The Chinatown ceremonial gate was built adjacent to the large high-rise in the background in 1986.

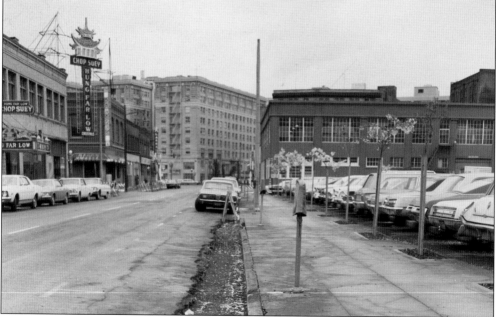

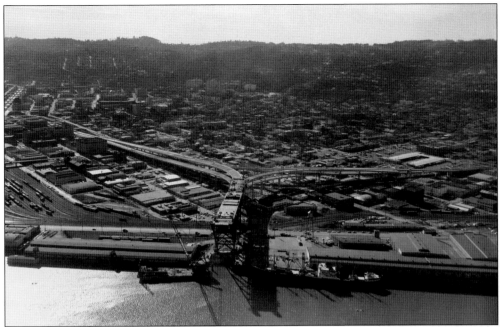

In 1973, the Fremont Bridge was still under construction. In this image, the center section of the bridge is yet to be lifted into place, and the Pearl District is off to the left. The bridge and freeway ramps dwarf the surrounding industrial buildings and the railroad yards. The interstate system in general has come to dominate and alter the transportation landscape in the entire country.

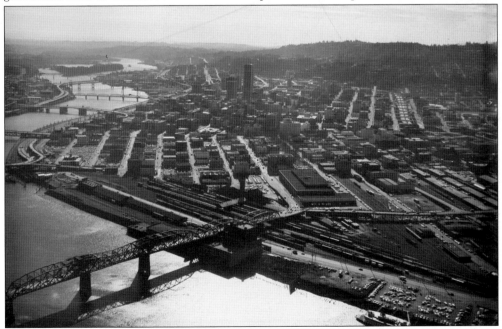

Looking southwest from the Fremont Bridge in 1973, the Union Station Yard is filled with railcars; the area is still an industrial landscape. The differences in the street pattern between Couch's Addition and the original Portland plat to the south also clearly stand out. Portland streets were laid out in relation to the riverbank, while those in Couch's Addition were oriented to true north.

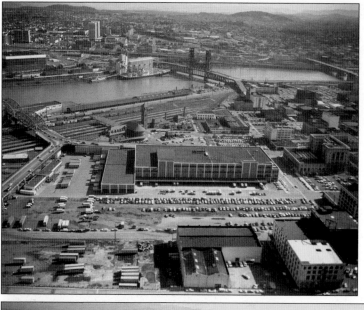

Constructed in 1964, the main US Post Office and associated parking areas take up a considerable amount of land just to the west of Union Station in 1975. It continues to process the mail from all of Oregon and southwestern Washington today, but some would like to see it removed in order to make way for new urban development.

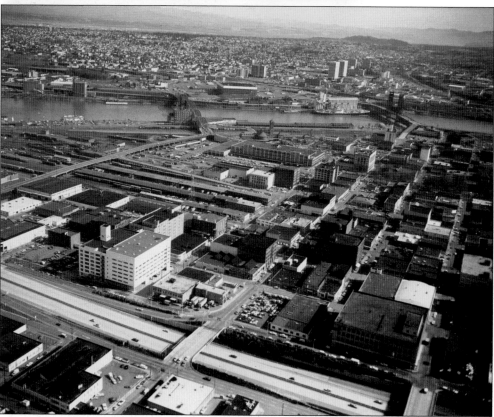

The western edge of the Pearl District is I-405, which stands out as a wide barrier between the Pearl District and the Alphabet District to the west in 1975. This continues to be the case today and may be why the Pearl has been expanding to the east and north rather than further west beyond the freeway despite the availability of some industrial buildings just west of I-405.

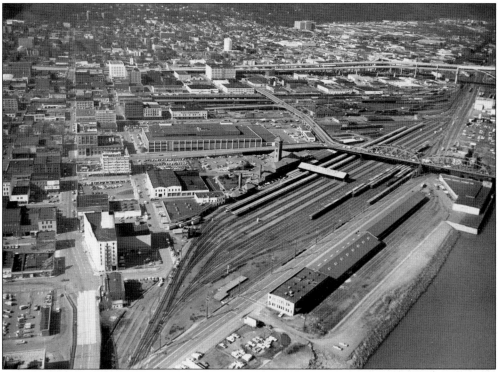

Some changes are beginning to appear in the landscape of Couch's Addition, soon to be the Pearl District, in 1975. Several tracks at the south end of Union Station Yard have been removed next to the bridge ramp, and the warehouse area on the river north of the Steel Bridge looks relatively abandoned. That site will become the McCormick Pier Apartments and later condominiums, beginning in 1982.

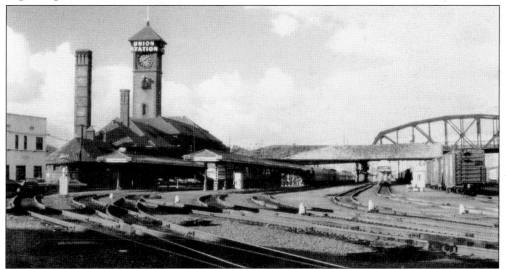

Union Station and its adjacent rail yard appear here in 1979. The yard extends all the way out to NW Front Avenue on the right and is filled with railcars and passenger trains. The gray roof that extends to the right of the main station building is the original rail shed, which protected passengers from the weather as they walked in from the outer tracks. (Courtesy of the author.)

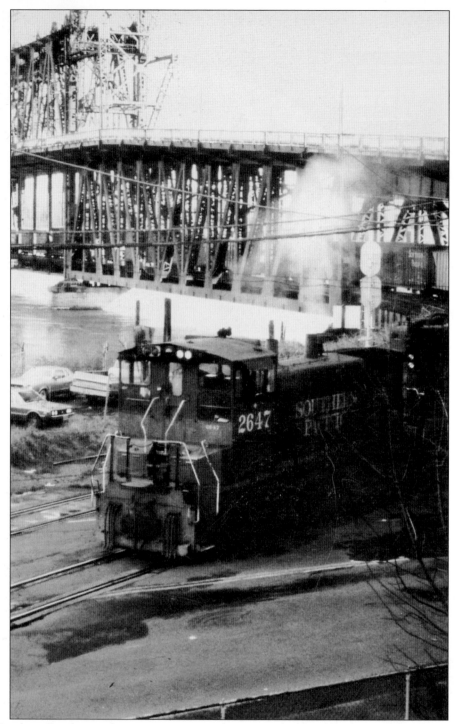

A Southern Pacific switch engine emerges at the west end of Steel Bridge in 1979. This engine would have been moving cars from the Southern Pacific's Brooklyn Yard to the south into the Union Station Yard, Hoyt Street Yard, or the Lake Yards of the Burlington Northern Railroad. (Courtesy of the author.)

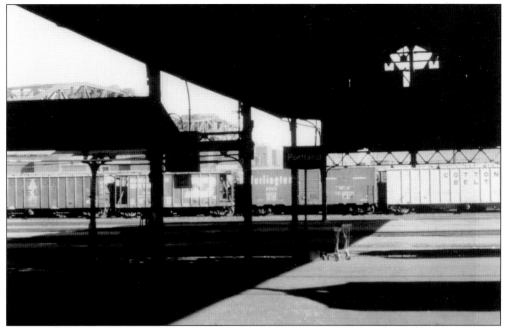

As passengers walked out to board a train at Union Station in 1981, they are greeted by the sight of railroad cars in the station yard on the east side of the building. The yard was closed soon after this, eventually becoming home to apartments and automobiles. (Courtesy of the author.)

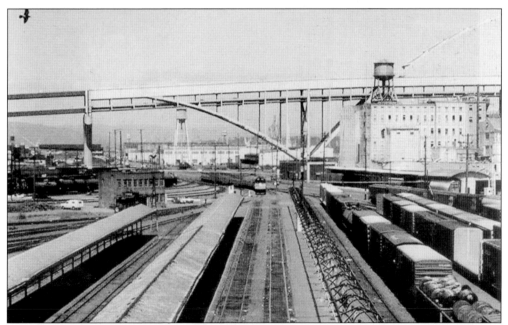

Pictured here from the Broadway Bridge, an Amtrak train approaches the station in 1979 at the north end of the Union Station Yard. The rails associated with the covered walkways were often used by passenger trains or through trains. The rails to the right were for general freight cars. Note the dilapidated condition of the walkway covering just to the left of the freight cars. (Courtesy of the author.)

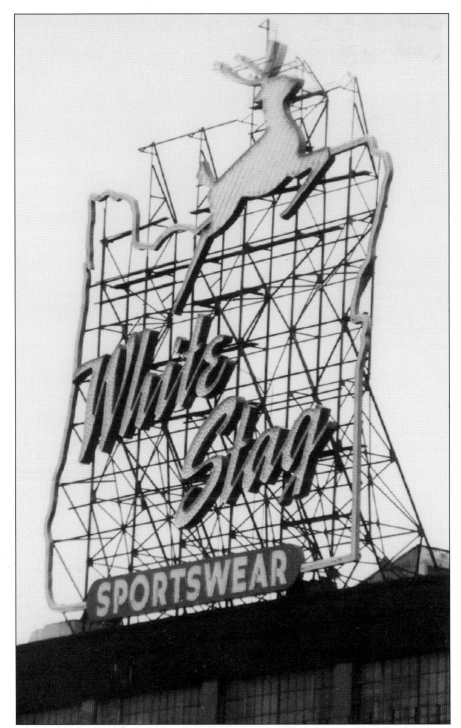

When it was first erected in 1940, this lighted sign advertised the White Satin sugar company. In 1959, it advertised White Stag, a sports apparel company at that location. The White Stag sign had illuminated the west end of the Burnside Bridge for nearly four decades when it was switched, first to Made in Oregon and, more recently, to Portland Oregon. (Courtesy of the author.)

Four

DECLINING INDUSTRIAL ACTIVITY

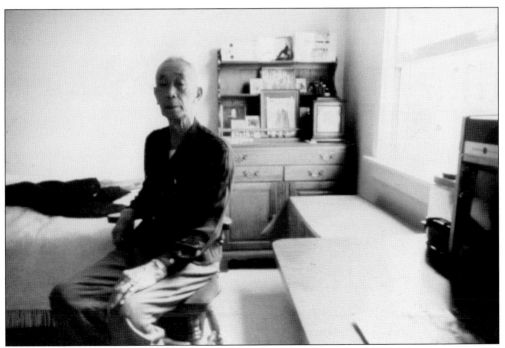

An elderly Asian man is pictured in his apartment in 1970. Many poor and older people came to live in the aging hotels of the area known as SROs, for Single Room Occupancy. These hotels once housed industrial workers.

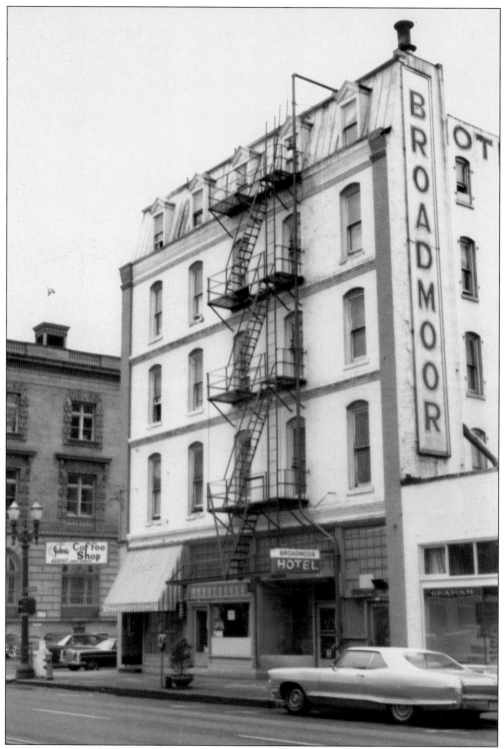

The Broadmoor Hotel at 307 NW Broadway is pictured here in 1976. Between 1906 and 1931, this hotel was the focal point of African American cultural life in Portland.

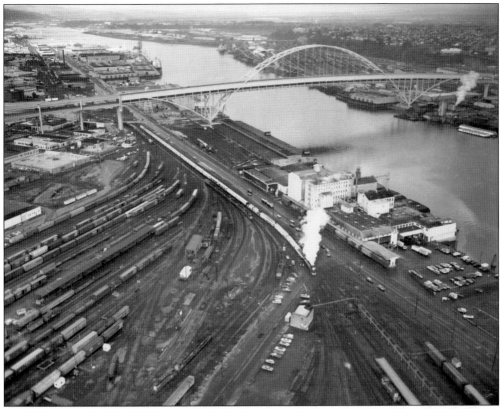

The Bicentennial Freedom Train, led by Portland's own Southern Pacific *Coast Daylight* Engine 4449, steams into Portland from the north in 1975. Behind the engine stands the brand new Fremont Bridge connecting I-405 with I-5 on the east side of the river. To the left is a grain operation, and to the right is the Hoyt Street Yard.

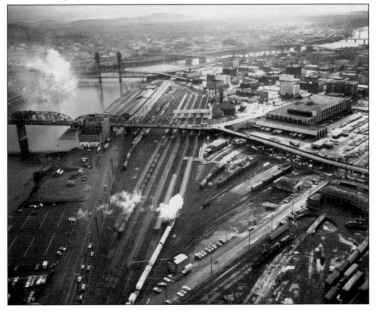

The Bicentennial Freedom Train, led by Southern Pacific's 4449, approaches Portland's Union Station in 1975. The engine pulled a set of cars exhibiting US history, on display at the station during its stay in Portland. To the right of the 4449 and on this side of the Lovejoy Ramp, the roundhouse for the Hoyt Street Yard is visible, as is the turntable.

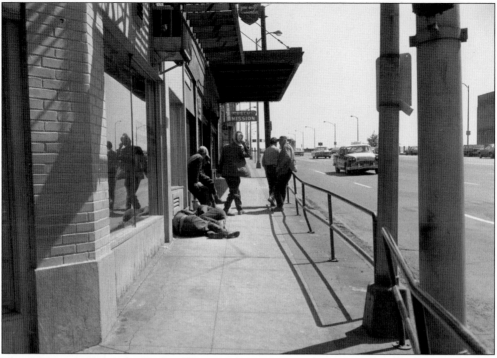

This 1973 image shows the Portland Rescue Mission area at the west end of the Burnside Bridge. Note that transients are lying on the sidewalk as others loiter nearby.

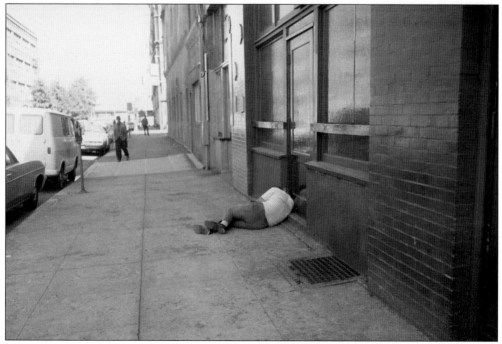

This image shows an apparently inebriated man who has fallen down on the sidewalk on NW First Avenue near Burnside in 1973. As this part of town declined, it attracted more and more low-income and homeless individuals.

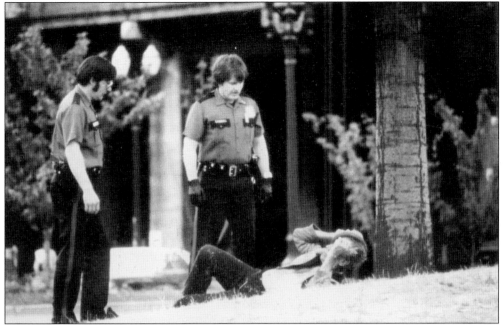

In this photograph, taken in Waterfront Park at the Burnside Bridge in 1979, two Portland police officers confront an intoxicated man. Common this area, intoxicated transients are often transported to a local detoxification center where they can safely sober up before release. (Courtesy of photographer David Gorsek.)

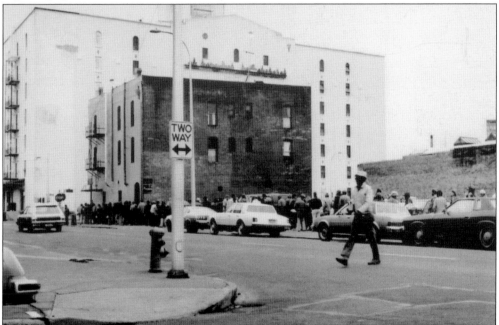

People are lined up for a free meal at the Blanchet House, a social service organization in Old Town at NW Third Avenue and NW Glisan Street, in 1984. Begun by students at the University of Portland and named for a Catholic archbishop, the Blanchet House first opened in 1952. (Courtesy of the author.)

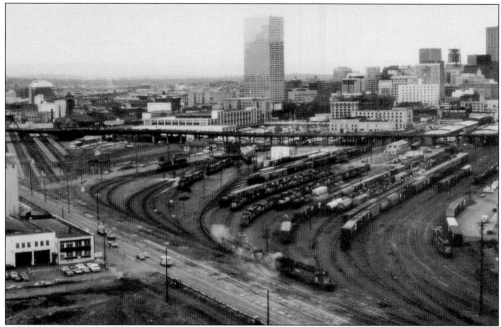

An active Hoyt Street Yard is visible to the south of the Fremont Bridge in 1983. The yard stretched back from the smoke-belching Burlington Northern engines along NW Front Avenue to the long Lovejoy Viaduct. The viaduct ran from the end of the Broadway Bridge and Union Station on the left toward NW Fourteenth Avenue on the right. (Courtesy of the author.)

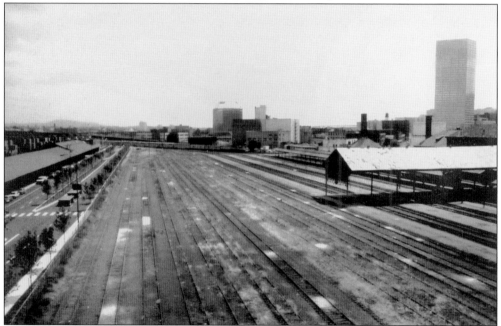

Things changed quickly at the Union Station Yard during the early 1980s. The yard appears empty in this sweeping 1984 image of the front of the station. Only the main lines were being used to any major extent. At the far south end of the yard, the northbound *Coast Starlight* is entering from the Steel Bridge on that mainline route. (Courtesy of the author.)

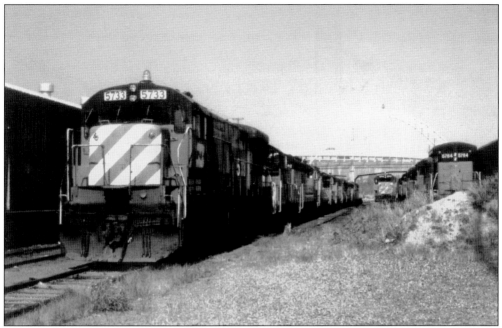

Burlington Northern engines are being stored on track south of the Lovejoy Viaduct and next to a train shed in this 1983 image showing the viaduct and the Fremont Bridge to the north. This was a far cry from the activity that used to occur in the Hoyt Street Yard. (Courtesy of the author.)

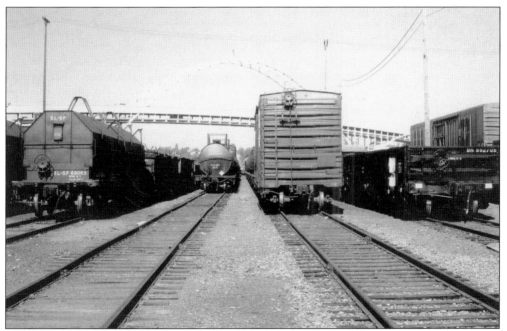

This part of Hoyt Street Yard in 1983 was north of the Lovejoy Viaduct. The Fremont Bridge is in the distance, and there are numerous railcars sitting in the yard that appear to be in storage. These cars provided a historic reference to bygone days, as their old company names had not been painted over. (Courtesy of the author.)

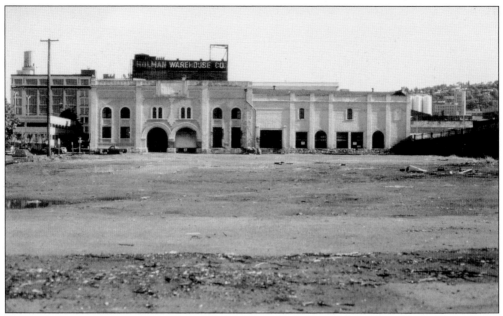

Pictured here in 1990, this wide expanse in front of an industrial building between NW Ninth and Tenth Avenues on Johnson Street was once an industrial site itself. In later years, the buildings were removed, and the area was used for parking semitrailer trucks before being totally abandoned. The remaining structure with the white facade is now Ecotrust. (Courtesy of the author.)

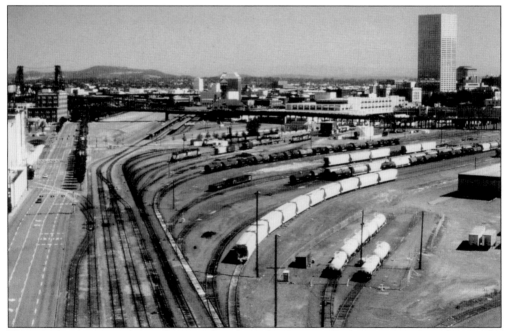

This 1995 image is similar to the one taken from the Fremont Bridge in 1983. Note that on the east side of Union Station (to the left), grass has replaced the railroad yard. A number of tracks have also been removed from the Hoyt Street Yard to the right. (Courtesy of the author.)

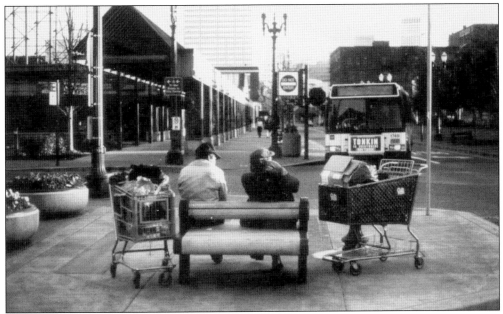

Two homeless men sit and talk on a bench in front of Union Station across from the Greyhound Bus Station in the mid-1990s. Homelessness continues to be a problem in this area, despite the new development in the Pearl District. This leads to what some have called contested space. In this case, urban spaces are being claimed by new, upscale homeowners along with the low-income and homeless individuals who called the area home before their arrival. (Courtesy of the author.)

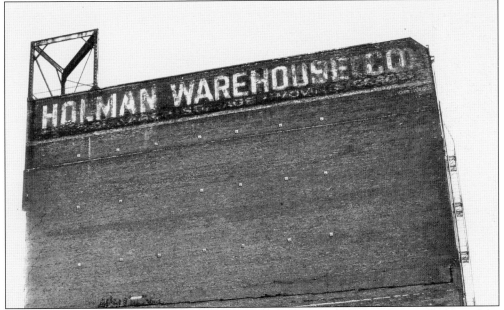

This was the Holman Warehouse Company. Large, multistory warehouses were a big part of the pre-Pearl industrial landscape, as seen in earlier photographs. Pictured here in 1993 at NW Ninth Avenue and Hoyt Street, this building was needed for storage when rail was the primary mode of transporting industrial goods. Industry now prefers single-story structures with good freeway and highway access for trucks, likely to be found out in the suburbs. (Courtesy of the author.)

The Blitz Weinhard Brewery was a going concern in Portland in this 1994 photograph. The brewery utilized rail shipments for its operations, which brought freight cars deep into the Pearl District. This set of cars is on NW Thirteenth Avenue between Burnside and Couch Streets. The operation was closed in 1999 and has since been redeveloped as a combination of housing, retail, and office space. (Courtesy of the author.)

A Burlington Northern switch engine picks up a railcar at the Meier and Frank Warehouse at NW Fifteenth Avenue and Hoyt Street in 1995. This was an unusual event by then, but in the past it had been common practice. Boxcars were shuttled from the Hoyt Street or Union Station rail yards out to the various industrial and warehouse buildings in the Pearl to offload needed goods and supplies. (Courtesy of the author.)

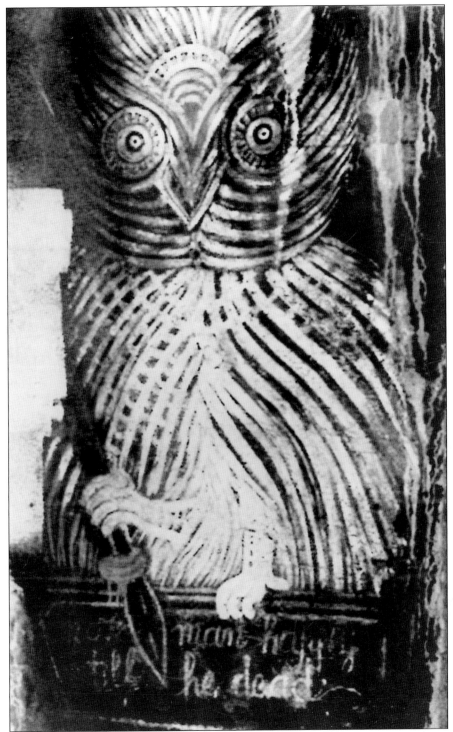

Located on a support column for the Lovejoy Ramp, the *Owl*, painted by railroad worker Tom Stefopoulos in the late 1940s or early 1950s, was part of his artwork relating to Greek culture, as is the *Tree Man* image on the next page. (Courtesy of the author.)

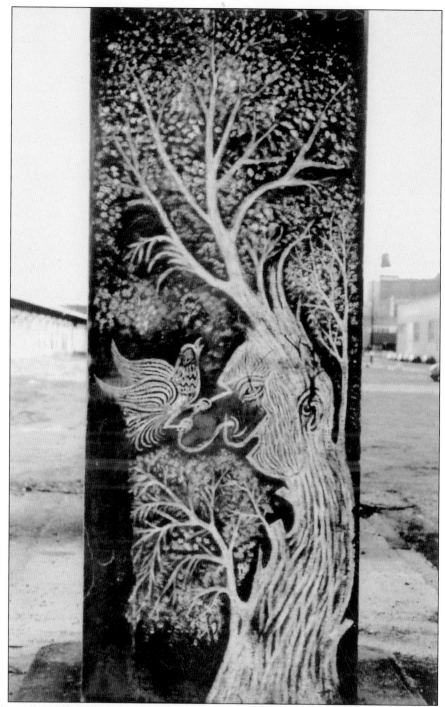

While graffiti, especially tagging, has been looked down upon by many, some murals and drawings have been hailed as important artifacts to save and cherish, such as this image, showing the *Tree Man*. With the demise of the Lovejoy Viaduct in 1999, several of Tom Stefopoulos's images were preserved, and in 1995, two of them were moved to the Elizabeth Lofts on NW Tenth Avenue for permanent display. (Courtesy of the author.)

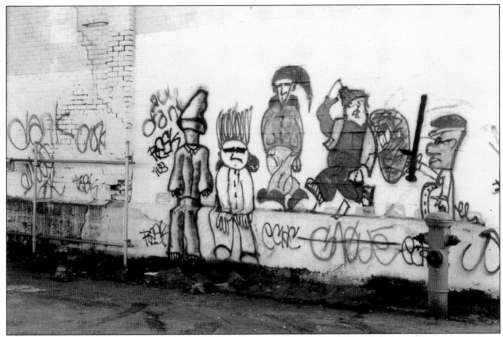

By the late 1990s, hip-hop graffiti had become a serious issue in Portland. Not only did it spring up on the walls of many industrial buildings in the city, it also found its way onto many railroad cars. This mural was painted on a building near the west end of the Lovejoy Viaduct. (Courtesy of the author.)

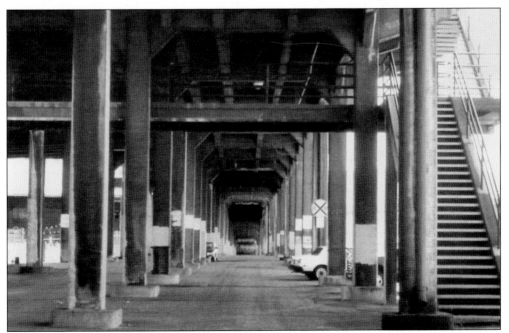

As one can see in this photograph, this location was quite invisible to most people, even those driving over the viaduct, and therefore made for an excellent place to practice illegal artwork, otherwise known as graffiti. (Courtesy of the author.)

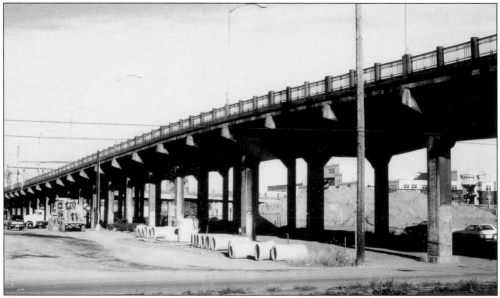

Construction in some sections of the Hoyt Street Yard was under way by 1997. With the rails gone, the Lovejoy Ramp was seen as an impediment to growth. Because of that, it was removed and replaced by a shorter ramp from the Broadway Bridge and a ground-level street lined with high-rise housing and business ventures. (Courtesy of the author.)

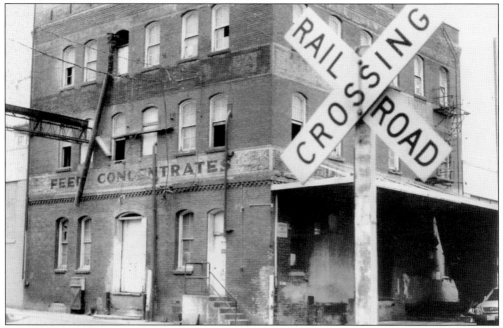

In 2006, this aging industrial plant at NW Thirteenth Avenue and Marshall Street was located along an avenue that was once lined with warehouses and light industrial facilities. A 1940 Union Pacific publication touting its industrial properties in the Pacific Northwest had a map displaying just that, with rail service provided by the Northern Pacific Terminal Company. It shuttled freight cars back and forth between NW Thirteenth Avenue industry and the surrounding railroad yards. (Courtesy of the author.)

Five

AN EMERGING
URBAN OASIS

By the late 1990s, the former Hoyt Street Yard property was being advertised as a new neighborhood with both residential and commercial land uses. Painted on the sign, the landscape included a stream, which was to be Tanner Creek, resurrected from the sewer. Unfortunately, that part of the plan never materialized. (Courtesy of the author.)

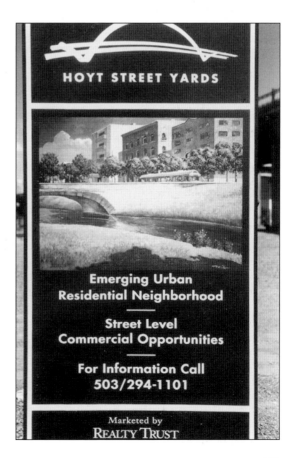

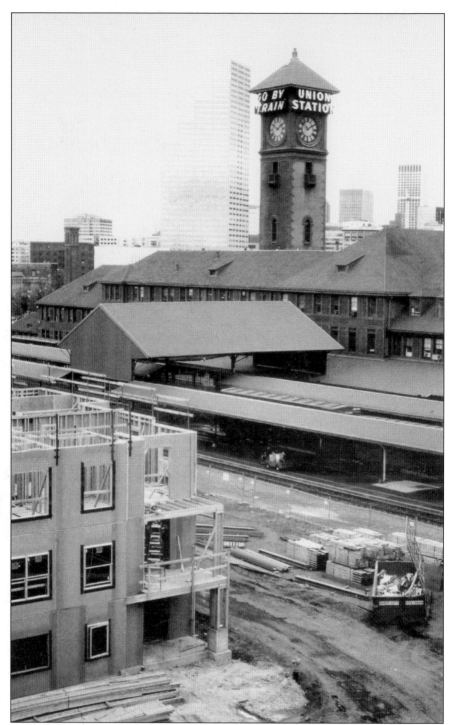

In this 1997 photograph, an apartment complex named the Yards at Union Station is under construction in front of the station, where the railroad yards once sat. This is not an unusual occurrence in the United States, as toponyms, or place names, frequently commemorate things that used to be there. (Courtesy of the author.)

Fast, comfortable regional transportation is provided to the city by Amtrak *Cascades* trains. In 2011, trains like this one link Portland with Eugene to the south and Vancouver, British Columbia, and Seattle to the north. People in the Pearl District have ready access to this system at Union Station and can travel across the Pacific Northwest or the rest of the country via Amtrak's long-distance fleet. (Courtesy of the author.)

The Pearl District is located at an important focal point of transportation in the Portland area. Train travel and bus travel are readily accessible, whether local or long distance. In the late 1980s, passengers are seen boarding a Greyhound bus in the evening at the terminal across from Union Station. (Courtesy of the author.)

A Trimet Bus on the Fifth Avenue Transit Mall just south of Union Station is ready to depart for Oregon City in 2011. The Transit Mall on the east side of the Pearl District provides Max light rail and bus service to area residents, which connects them to the rest of the metropolitan area. (Courtesy of the author.)

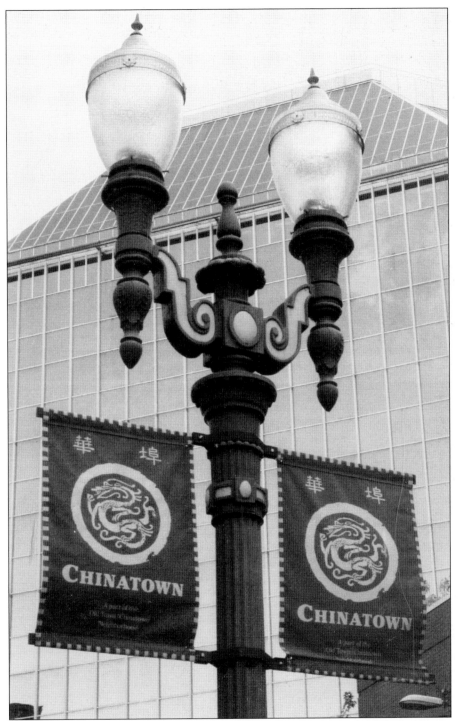

In this 2007 image, a set of Chinatown signs is visible on a city lamppost. The post is painted in red with gold highlights and is dwarfed by a large high-rise office building behind it in Old Town. While many cultural organizations and restaurants still reside here, most of the residents of Chinese descent have moved elsewhere. (Courtesy of the author.)

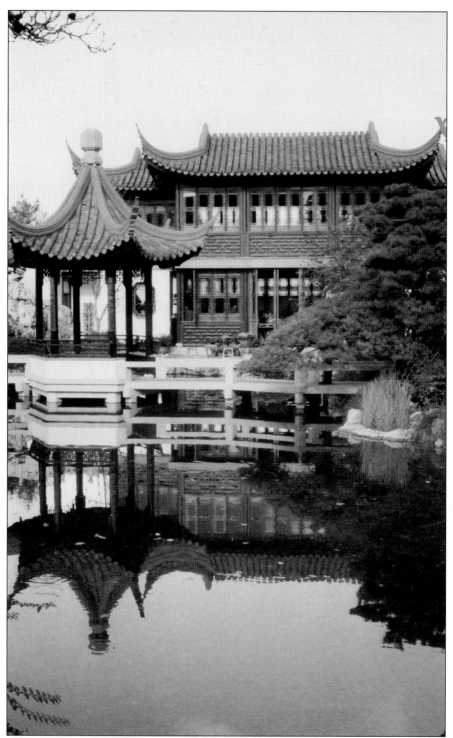

Portland's Lan Su Chinese Garden is pictured here in 2007. It was opened in 2000 and is located at NW Third Avenue and Everett Street, providing an important cultural site both for Chinatown and the Pearl District. (Courtesy of the author.)

This 2008 photograph depicts one of the plaques found in the Japanese-American Historical Plaza. It is located at the north end of Waterfront Park along the west bank of the Willamette River. Opened in 1990, the memorial is designed to commemorate the internment of Japanese citizens during World War II. (Courtesy of the author.)

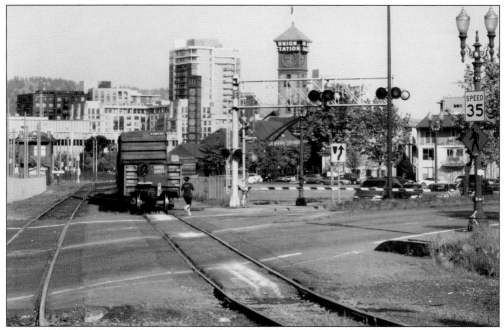

This photograph from 2011 captures the land-use contrasts that are still found in the Pearl District. Looking closely, one can see passing the end of a freight train a jogger who undoubtedly lives in one of the area's new condos or apartments as the train heads north toward the Burlington Northern's Lake Yard. (Courtesy of the author.)

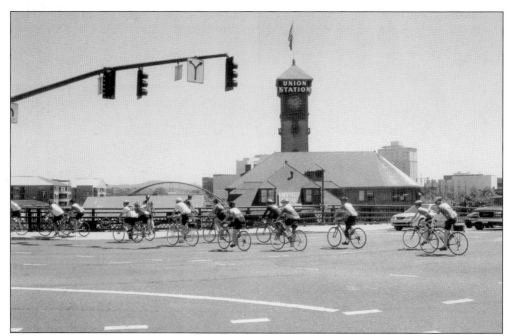

This 2007 photograph of Union Station and the west end of the Broadway Bridge shows that bicycles are quite popular in the Pearl District. Bike lanes and street-level reference maps are readily available for navigating through the area. (Courtesy of the author.)

This is an image of the Lovejoy Ramp and Street from the west end of the Broadway Bridge in 2006. Once filled with railroad tracks, this area is now dominated by new businesses and residential housing. In the distance, one can see the Marshall Wells Lofts building at NW Fourteenth Avenue. (Courtesy of the author.)

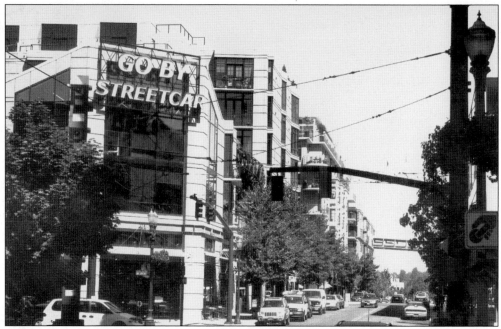

This building at NW Eleventh Avenue and Lovejoy Street combines street-level business activities with upper-level housing and sports a Go By Street Car advertisement reminiscent of the Go By Train sign on the Union Station Tower. (Courtesy of the author.)

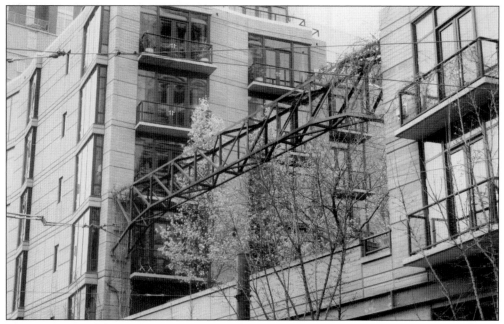

The south side of the Go By Street Car building at NW Eleventh Avenue and Lovejoy Street appears here in July 2008. This building has an interesting design, integrating an old-style steel skeleton like those used to transport material back and forth above street level between industrial buildings into this new high-rise residential structure. (Courtesy of the author.)

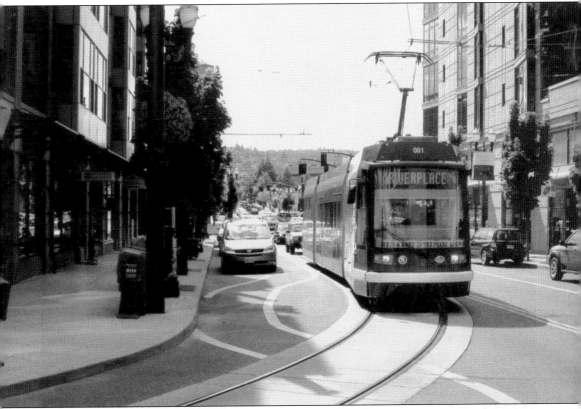

Here, a streetcar is visible on NW Eleventh Avenue and Lovejoy Street in 2011. This system connects the Pearl District to Portland State University and the new urban development in the North Macadam area as well as to the Oregon Health Sciences University to the south and to Good Samaritan Hospital and the upscale NW Twenty-third Avenue District to the west. (Courtesy of the author.)

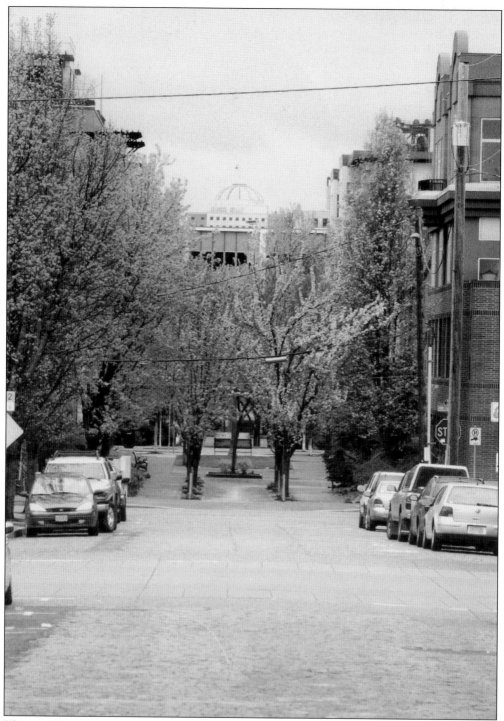

This is NW Kearney Street west of Thirteenth Avenue looking east in April 2011. Note that the street in the foreground is cobbled, which is most likely the original street-paving material. While the street grid is maintained east of NW Twelfth Avenue, the street itself has been replaced by a tree-lined pathway. (Courtesy of the author.)

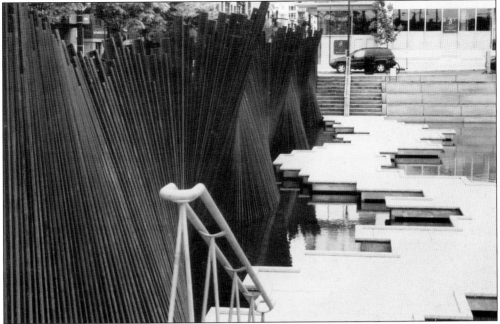

This is an image of the eastern side of Tanner Springs Park in 2008. This park has a series of artificial streams and a pond reminiscent of the early landscape. The wall in this image is made up of old rails, recalling the industrial landscape that replaced those lakes, streams, and wetlands but that has now disappeared as well. (Courtesy of the author.)

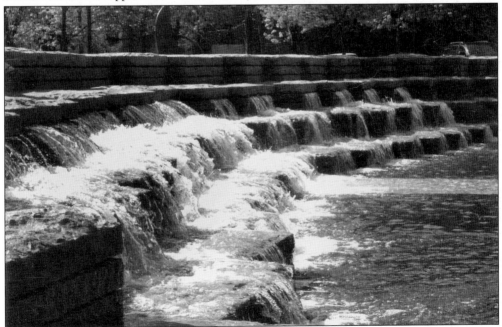

This water feature in Jamison Park in 2011 looks like a low waterfall and fills the symbolic coastal tide pool at its base. This was the first park to be developed in the new Pearl District. Popular with children, it is named for William Jamison, an art gallery owner and early supporter of this renewed area. (Courtesy of the author.)

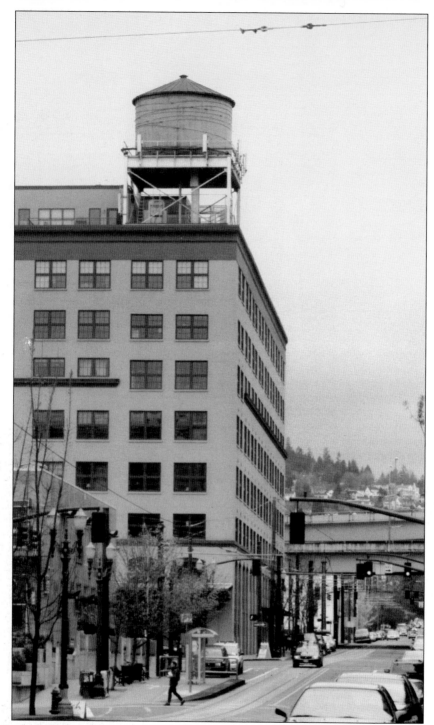

The Marshall Wells Lofts are at 1420 NW Lovejoy Street. This building is an old seven-story warehouse that now contains 164 loft homes. Note the water tower on its roof. Many of the buildings in the area have these towers, which were used in warehouses to provide water for fire suppression. (Courtesy of the author.)

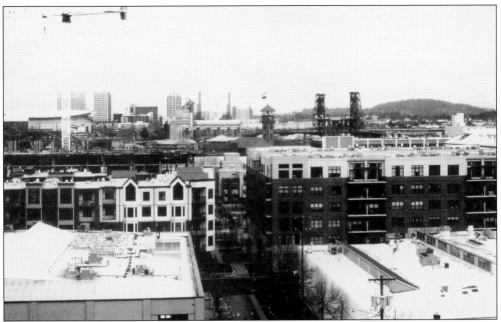

This photograph shows the view from a condominium in the Marshall Wells Building at NW Fourteenth Avenue and Lovejoy Street in 2004. Looking east across the Pearl District toward Union Station, the Steel Bridge and the convention center towers are visible, while a high-rise residence is under construction in the mid-ground. (Courtesy of the author.)

This former Burlington Northern building at NW Eleventh Avenue and Irving Street has now been converted to condominiums. This 2011 photograph shows how past industrial elements have been integrated into this new living space. (Courtesy of the author.)

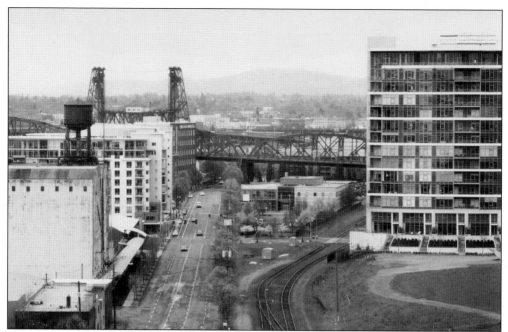

The Pearl District is pictured here from the Fremont Bridge in 2011. Note how the area along NW Front Avenue has substantially filled in since 1995. To the right of the photograph are still some open areas, but another park and more buildings are currently planned for that space. (Courtesy of the author.)

This is an example of some of the more subtle design elements visible at the street level. This piece of street art is a rendition of the nearby Fremont Bridge. It could also be used to secure a dog or bicycle. (Courtesy of the author.)

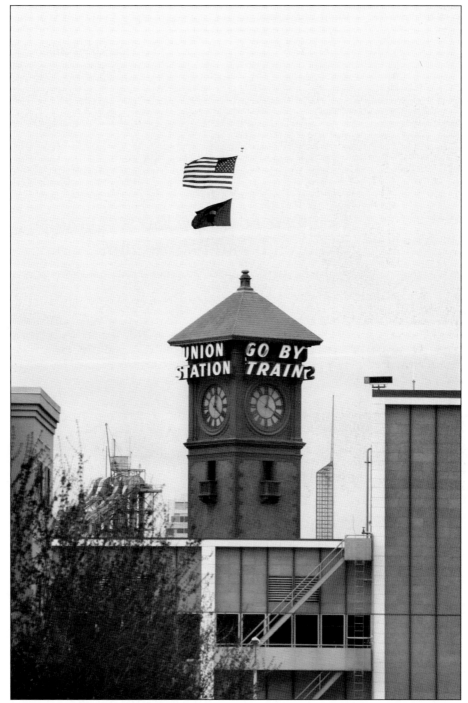

Union Station's 150-foot-tall clock tower continues to rise up over the Pearl District. When first constructed in 1896, it looked out over a rapidly industrializing section of the city. The station and its tower have evolved over time, as has the landscape beneath them. The neon Go By Train and Union Station signs were added in 1948. Industry has now faded, and a new urban residential neighborhood is taking shape. (Courtesy of the author.)

Discover Thousands of Local History Books
Featuring Millions of Vintage Images

Arcadia Publishing, the leading local history publisher in the United States, is committed to making history accessible and meaningful through publishing books that celebrate and preserve the heritage of America's people and places.

Find more books like this at
www.arcadiapublishing.com

Search for your hometown history, your old stomping grounds, and even your favorite sports team.